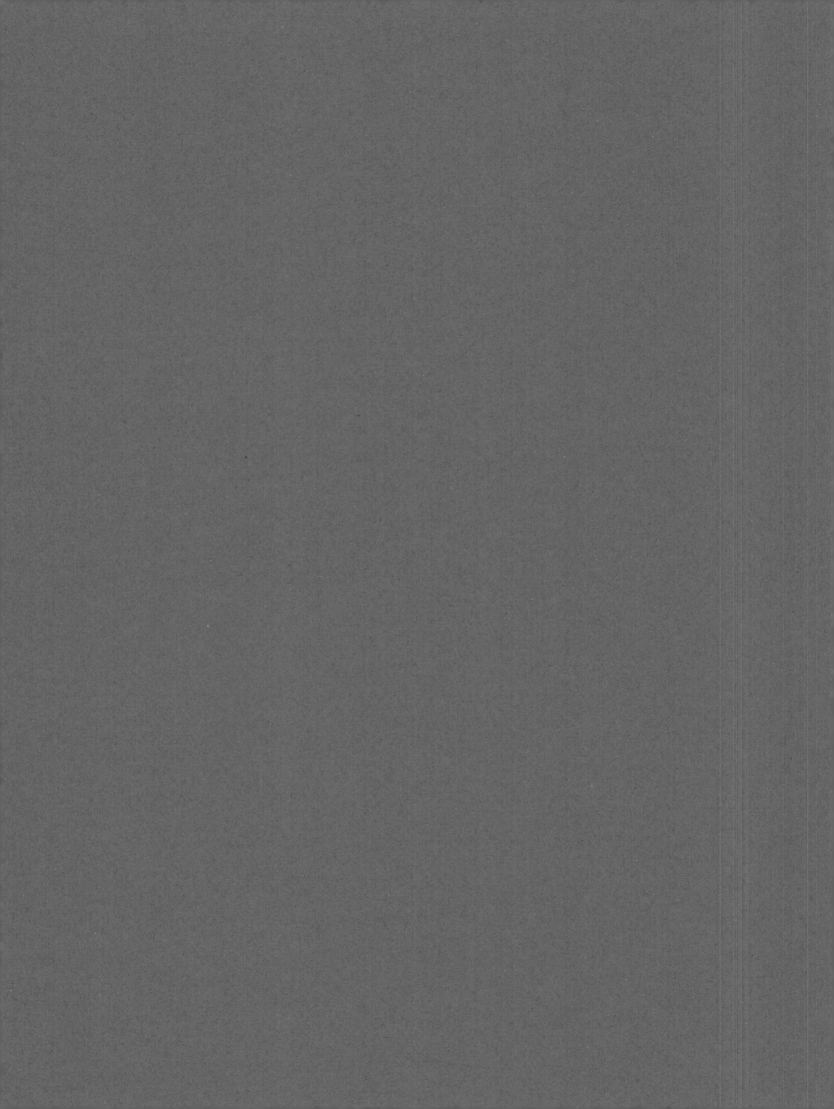

THE ART OF BEV DOOLITTLE

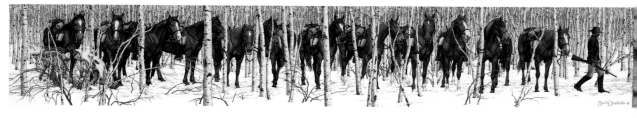

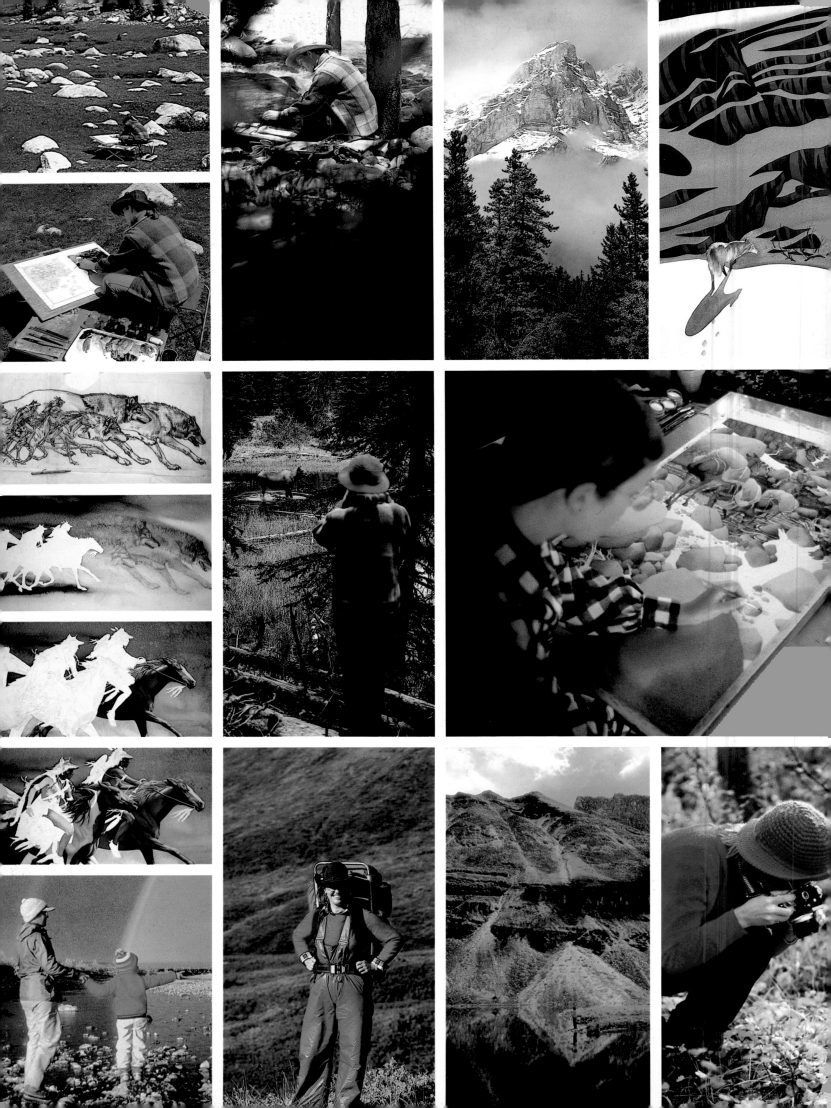

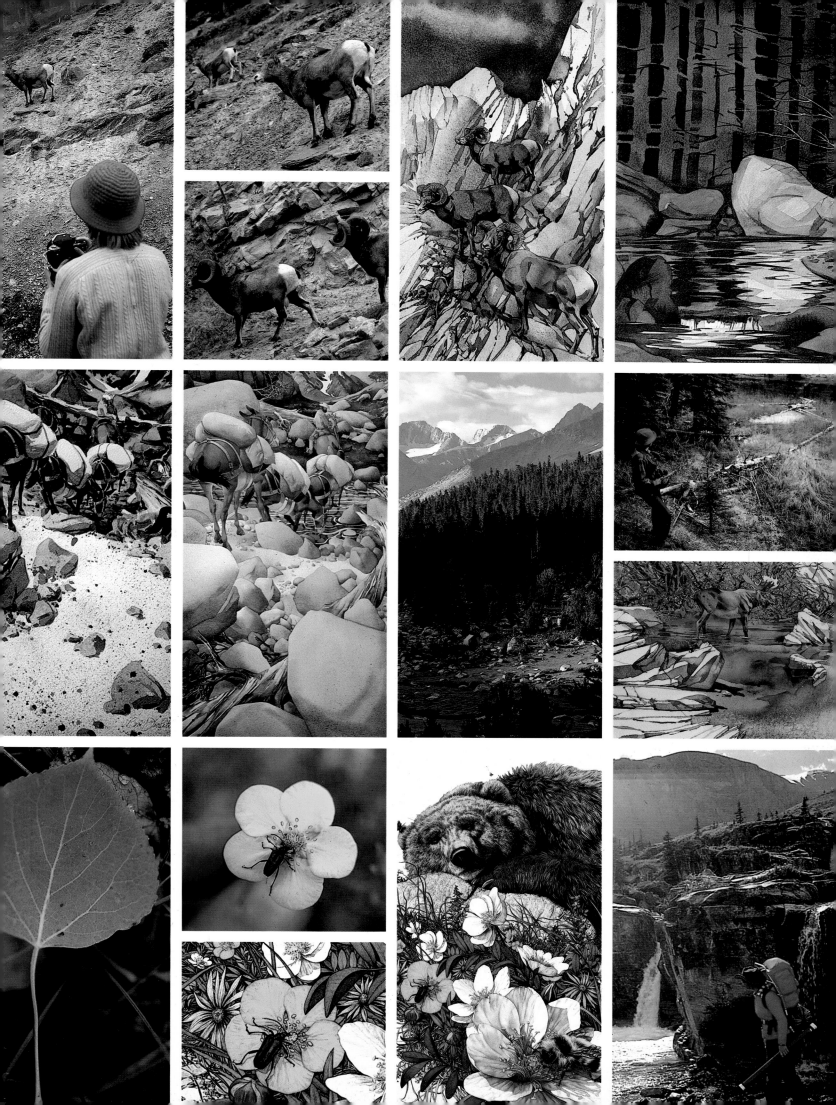

THE ART OF
BEV DO

TEXT AND POEMS BY ELISE MACLAY
EDITED BY BETTY BALLANTINE
DESIGNED BY LEN LEONE
BANTAM BOOKS · NEW YORK · TORONTO · LONDON · SYDNEY · AUCKLAND

LITTLE

ACKNOWLEDGMENTS

The Greenwich Workshop extends grateful thanks for quoted material which appears by the courtesy and kind permission of the following:

It's Me O Lord: The Autobiography of Rockwell Kent, Siena Publications; G.W. Eklund; Kathy Chase; Chaska Gomez; Calvin J. Goodman; Judy Hughes; Vivian Raisch; Jack Innes; Nancy Rose Shale; The Joshua Tree National History Association; *American Artist* Magazine, and *Wildlife Art News*.

THE ART OF BEV DOOLITTLE

A Bantam Book / October 1990

LIBRARY OF CONGRESS CATALOGING-IN-PUBLICATION DATA

Maclay, Elise.
The art of Bev Doolittle/by Elise Maclay;
edited by Betty Ballantine. —Bantam ed.
p. cm.
ISBN: 0-553-07009-6: $60.00 ($75.00 Can.)
1. Doolittle, Bev—Criticism and interpretation.
I. Ballantine, Betty. II. Title.
N6537.D594M33 1990
759.13—dc20 90-155
CIP

Published simultaneously in the United States and Canada

Printed in Italy by Amilcare Pizzi, S.P.A.

94 95 0 9 8 7

CONTENTS

A different way of seeing—

"When looking upon Bev Doolittle's works,
you are drawn into another world, another
place, another time, when everything
was a story and every story an adventure."
—Dan Smith, Art Director, National Wildlife

"Bev Doolittle's art meets not only the
eye, but also challenges our ability to perceive
beyond the surface of a colored image."
—Bernadette Johnson, Bernadette Gallery, North Vancouver, B.C. Canada

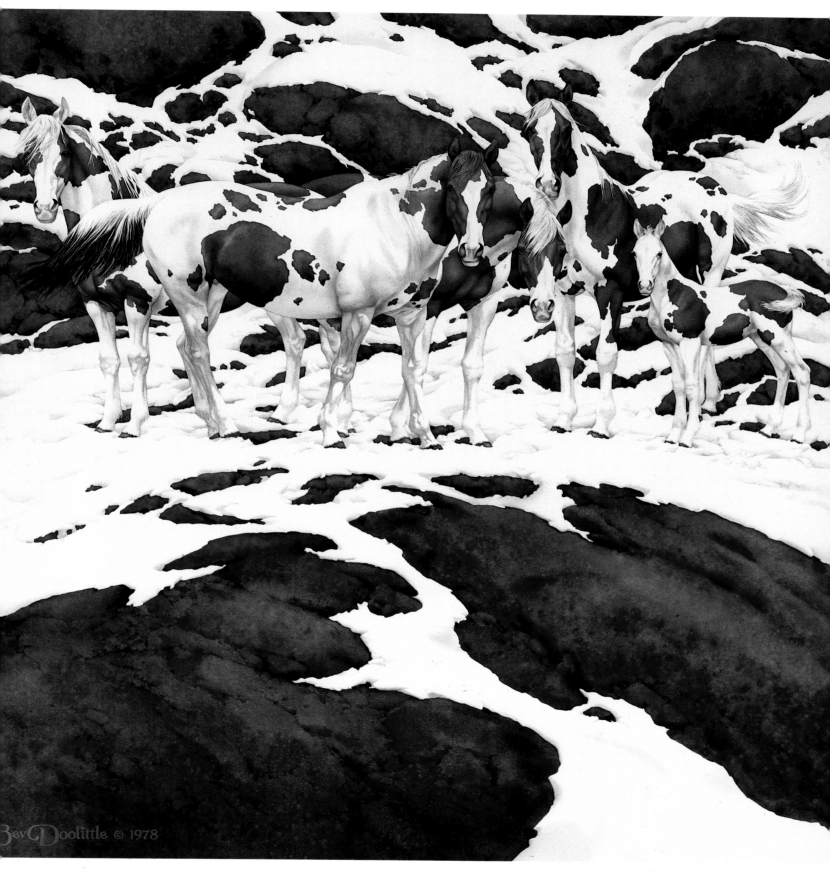

Bev Doolittle © 1978

PINTOS • 1979

1
PINTOS

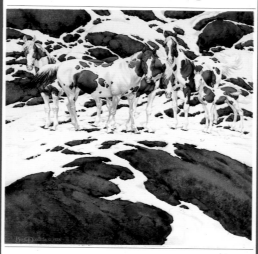

"In _Pintos_, the magic
began to happen for me."
—Bev Doolittle

In the fall of 1979, 1000 prints of *Pintos*, a watercolor painting by a relatively unknown artist named Bev Doolittle, were issued by The Greenwich Workshop, at a price of $65 each. By 1989, these prints were selling for as much as $10,000 each. But it is hard to find an owner willing to sell. What came to be known as "the Doolittle phenomenon" had begun. Doolittle's rare original works now command upwards of $150,000, and each set of limited edition prints sells out on release.

Experts trying to explain "the Doolittle phenomenon" cite the beauty of her work, the concepts, design, pattern and movement—"the viewer having fun 'discovering' what is beyond the obvious." One critic says, "Doolittle creates a twist, a turn. You're not seeing what you are seeing. That magic stays with people."

The original watercolor of *Pintos* is not for sale. It is the only original the artist cannot bring herself to part with. "For sentimental reasons," she says. If she were given to dramatic turns of phrase (and she is not), she might have said that this painting changed her life.

Pintos opened a door. Doolittle walked through to a world of possibilities that she began to explore. Painting after painting has resulted, each one pushing back new boundaries, each one eagerly received by collectors and excitedly "discovered" by people who don't ordinarily get excited by art.

The story of *Pintos*—how it came to be painted, what happened to it and to the artist afterward—tells much about Doolittle as an artist and as a person.

The drama begins with the struggling painter who almost gives up fine art and goes back to advertising illustration to earn a living. But she has begun an ambitious project—something she has always wanted to paint—a group of horses caught in the instant they scent an intruder. She has tried chestnut horses in a green meadow, but this kind of prettiness is not what the artist is after. She is trying to make the viewer feel the intense *awareness* with which the air is charged. In a sense, she is trying to paint what is unseen. She recasts the scene, setting it now in the mysterious red–rock desert country that surrounds her home in Joshua Tree, California. Still, something is missing. A sudden snowfall provides the answer.

"When I changed the meadow to a rocky pass and the chestnut horses into pintos, the magic began to happen for me. I entered the painting. I was in brand new territory. Sometimes, I'd even get lost. I made tissue overlays to find my way around."

The finished painting was startlingly realistic and at the same time had a strong abstract quality. It was not only unlike anything Doolittle had done before; it was unlike anything she'd *seen*. Somehow she knew that in *Pintos* she had found herself as an artist. What she could not know was that in *Pintos* the art world would discover Bev Doolittle.

Bev and her husband Jay were off to sell their wares at a local show, an outdoor show where the best paintings fetched a few hundred dollars at most. Bev packed up *Pintos*. Jay was appalled. "You're not going to take that!" "Why not? I'm sure it will sell." "That's what I'm afraid of!"

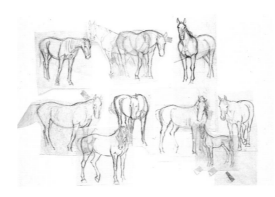
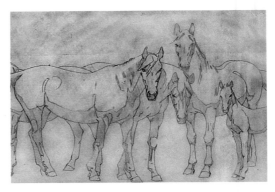

They argued the point for a while. They needed the money. Finally they agreed to make the price astronomically high. "No one will want to pay that much and if they do, we'll be rich."

At the show, Jay and Bev took turns minding store while one or the other made the rounds viewing the work of other artists. On one such foray, Jay returned to find Bev excitedly selling *Pintos*. "Oh, I'm sorry," Jay interjected. "It's been sold." When the disappointed would–be buyer was gone, Bev asked who had bought the painting. "We did," Jay said. "I just can't let you give your finest work away." "We needed the money," Bev says, "but I was so glad I still had *Pintos*. I really loved that painting. I kept wishing there were some way to sell it and keep it, too."

Although she rarely entered competitions, Bev decided to submit *Pintos* to The American Watercolor Society for possible exhibition in New York. At the time, the Society favored abstracts and she didn't really think they'd be interested—but it was worth a try. The Doolittles crated the painting and shipped it off. And indeed, the Society *was* interested.

At the exhibition in New York, *Pintos* caught the eye of an artist who phoned David Usher, president of The Greenwich Workshop. "You've got to come see this, Dave." Dave did and promptly called Bev Doolittle at her home in the desert near Joshua Tree. They talked and a short time later Dave flew out to Joshua Tree to see more of Bev's paintings and to arrange for the publication of a limited edition of *Pintos*.

Many paintings and many prints have been created since then. The interesting thing is that while the public fell in love with *Pintos* and would have been more satisfied with dozens of variations on its "camouflage" technique, Doolittle saw the camouflage idea as a beginning, one of many new worlds to explore.

Exploration takes nerve, tenacity and a capacity for hard work, all of which Doolittle has been able to sustain. Although she is a comparatively young artist, her art demonstrates the careful working out of several important new elements: the mysticism of what she calls her "spirit paintings"; her evocative story–telling quality; a playful way with complex pattern and design—the visual equivalent of music by Bach or Scarlatti.

While *Pintos* is interesting historically, it is important in and of itself. It is an ambitious painting that works. For the first time it brings together the particular talents of the artist—a disciplined painting style, an aptitude for planning and problem solving, her training as a designer, her attention to detail, and a totally original way of seeing. It is also, on the simplest level, a wonderful horse painting. The animals are beautiful, and although they are standing stark still, they are vibrant with life. At any moment, one feels, they will break and run.

"As long as I can remember," Bev Doolittle says, "I've drawn and painted horses. I love them." But it takes more than love to bring horses to life on a sheet of watercolor paper. All animals fascinate her, but from childhood on, she has spent hours watching horses, photographing them, reading about them. As a youngster she found a drawing of the skeleton of a horse in a research book. She copied it and presented the result to her startled mother. Although Bev rides whenever she gets a chance—her twin sister owns about twenty horses—she has never owned a horse of her own. "Now that I can afford one," she says, "I don't have time."

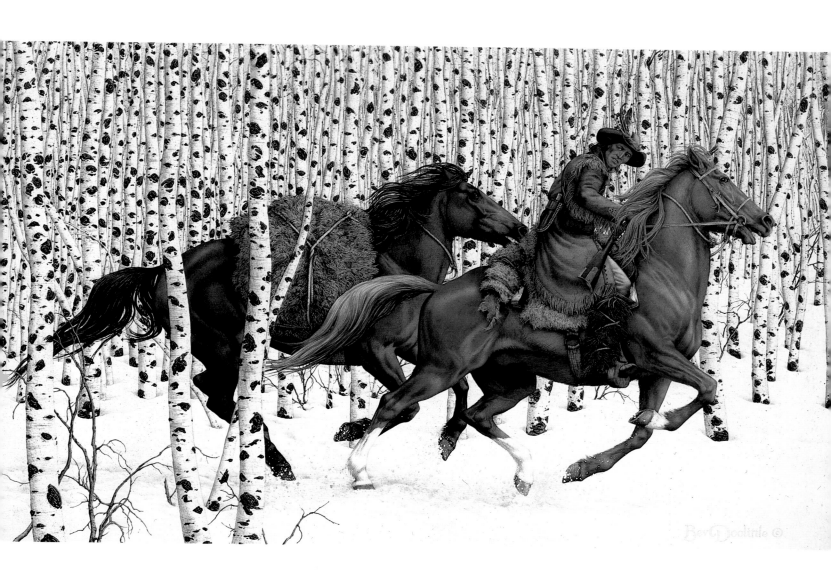

SACRED GROUND • 1989

"I want to change the experience of seeing." —Bev Doolittle

*What spirits guard lands held
holy by Blackfeet, Sioux and Crow?*

*In this camouflage painting Bev Doolittle
answers the question and shows us that there
are many levels to the visual experience.*

*Sacred Ground, Bev Doolittle's 1989 Personal Commission Print,
elicited requests for 69,996 prints—a new
record in the limited edition art world.*

CALLING THE BUFFALO
(Detail) • 1987

They say that when the land was young
And the buffalo herds were wide as day
But were far away and the people were hungry,
Men knew how to call the Buffalo Chief.
There were secret words,
And a sacred way to sound the horn,
So the herds would come
Wave on wave.
But only the brave, the true-hearted,
Knew.

In her spirit paintings Bev Doolittle shares
with us the wonder and awe with which the
Plains Indians regarded life on the American
prairie more than a hundred years ago.

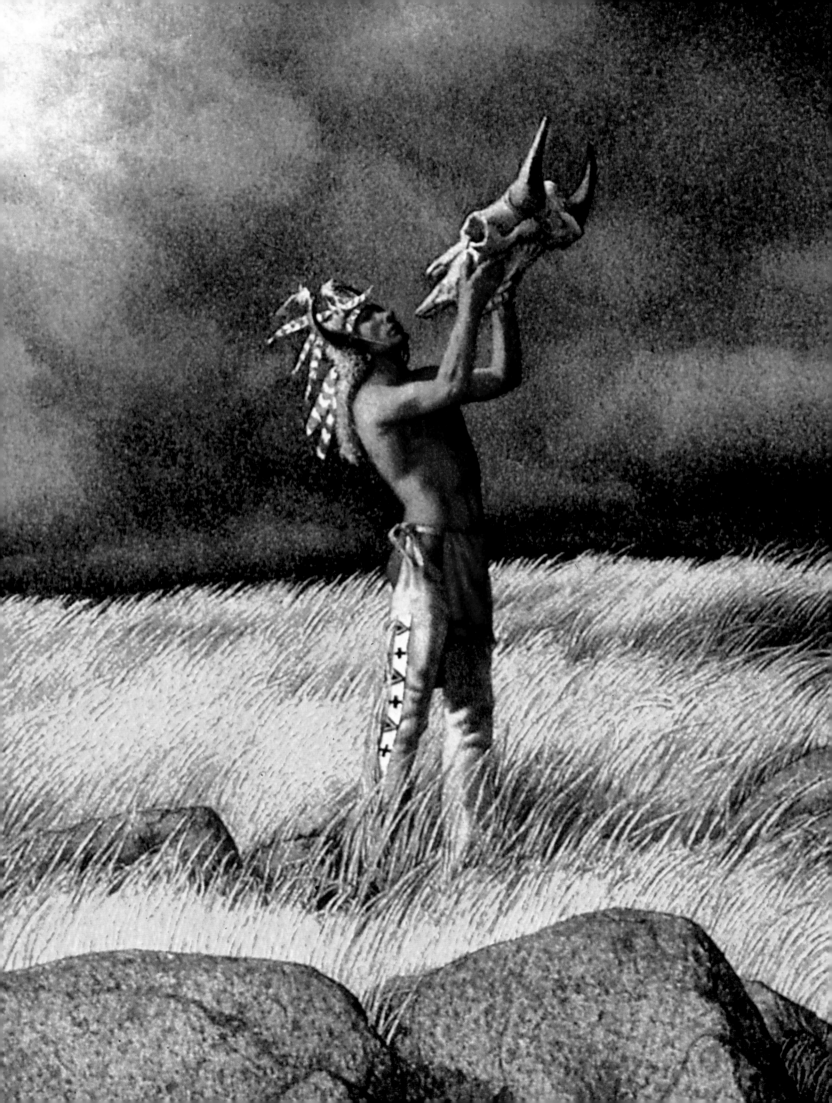

CALLING THE BUFFALO • 1987

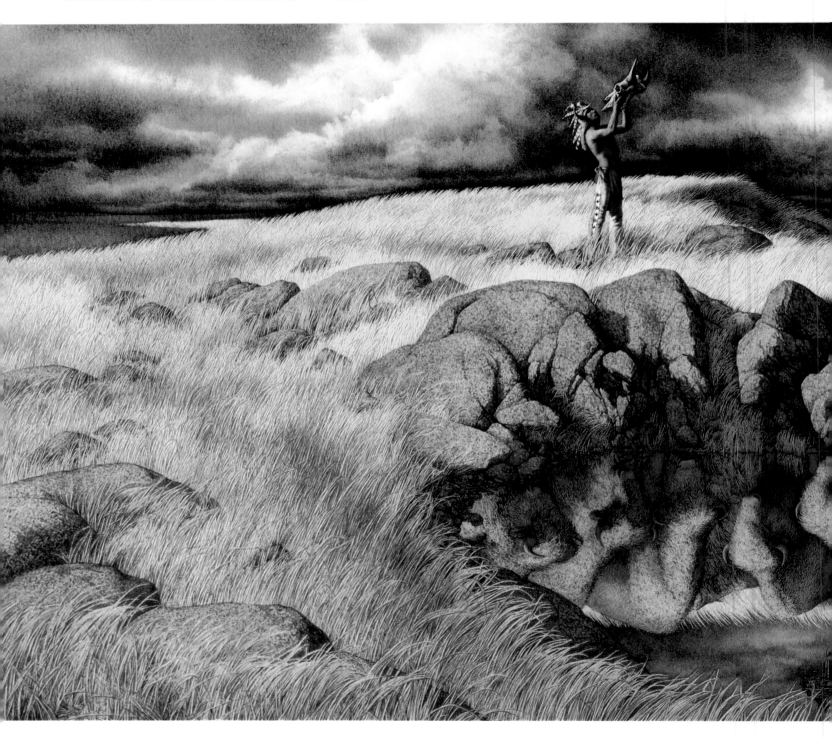

Bev Doolittle ©

2
IN PERSON

*"I believe that whoever
created earth did so
for the purpose of good."*
—Bev Doolittle

To meet Bev Doolittle is to be surprised and set at ease. There is so much hidden meaning in her art, so much mysticism in her spirit paintings, such communion with nature in her landscapes that one expects to meet a visionary, someone who lives on another plane, breathes rarified air and talks in blank verse. Instead one encounters a wide smile, a direct gaze, a sense of openness and optimism. Despite her disciplined painting technique with its awesome attention to detail, Doolittle strikes one as comfortable—with herself, with her family, with the world.

This sense of accepting and rejoicing is so strong one is tempted to imagine that she lives and has always lived separated from "real life"—family crises, work and career decisions, money matters and the everyday hassles of a twentieth century world. If she were not so removed, how could she have created a painted world of such serenity and exhilaration, peace and inspiration? Even in paintings where danger lurks, there is a calming sense that danger is part of the natural order of things. Visions, Doolittle's brush seems to be telling us, are for the most part good things, and fear, which is natural enough, too, is counterbalanced with courage and strength and joy.

Bev Doolittle was born and brought up in southern California. Her childhood, she says, was "ordinary." Her mother remembers that "Bev literally could draw as soon as she picked up a pencil. Even before she went to school, she had started drawing horses and people." Doolittle laughs. She drew, she says, because she grew up in a large family. "An ordinary family," she says, with some justification, since she is a member of what has come to be called a "blended family" with parents and step parents, two sisters, a brother, a step brother and two half brothers—not so unusual these days.

"One of my sisters," Bev says, "was three-and-a-half years older, so *she* always got to color the Disney characters in the coloring book. We younger kids couldn't color well enough—so I drew my own pictures." So much for the ill effects of sibling rivalry.

Her favorite subject, then as now, was horses, which she drew first with straight lines, then with a series of circles or a combination of circles and ovals. "It's a great technique. You can draw anything with ovals and circles. Much easier than doing it with boxes and perspective the way they tell you to in books. When I taught drawing at the Mission Art Center, I showed a group of seven-to-twelve year olds how to do it. But I couldn't remember where I learned it. Then recently, I was talking to my sister and she said, 'Oh, Mom told you how to do it that way.'"

Was her mother an artist? Doolittle says, "No, but she could have been. She was artistic but she was too busy raising a family to develop her talent." This recognition that art is time-consuming work is one that seems to have been with Bev from childhood. No one had to tell her that to become an artist requires constant practice. She was drawing all the time.

Not too long ago, her mother sent her a batch of drawings which she guesses were done when she was ten or eleven. "I don't remember doing these drawings, but as you can see I was really into the Western theme." Among these very early drawings are sketches of animal tracks, a subject Doolittle is currently exploring in connection with two African safaris she has taken in recent years. She laughs at her childhood rendition of a three-toed bear. "I've learned a few things about bears since then."

Right: Reproduction of grizzly track casting from original paraffin mold made by Bev Doolittle on site at Alatna River in the Brooks Mountain Range, northern Alaska. Shown in actual size.

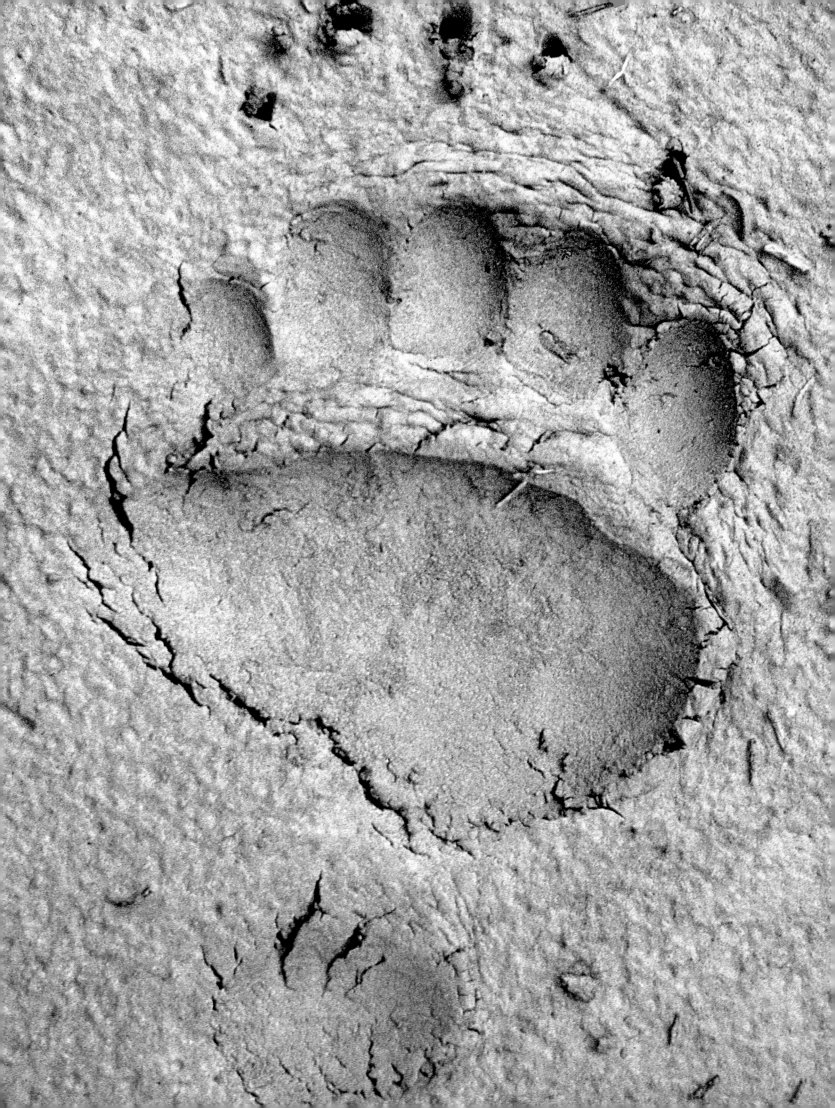

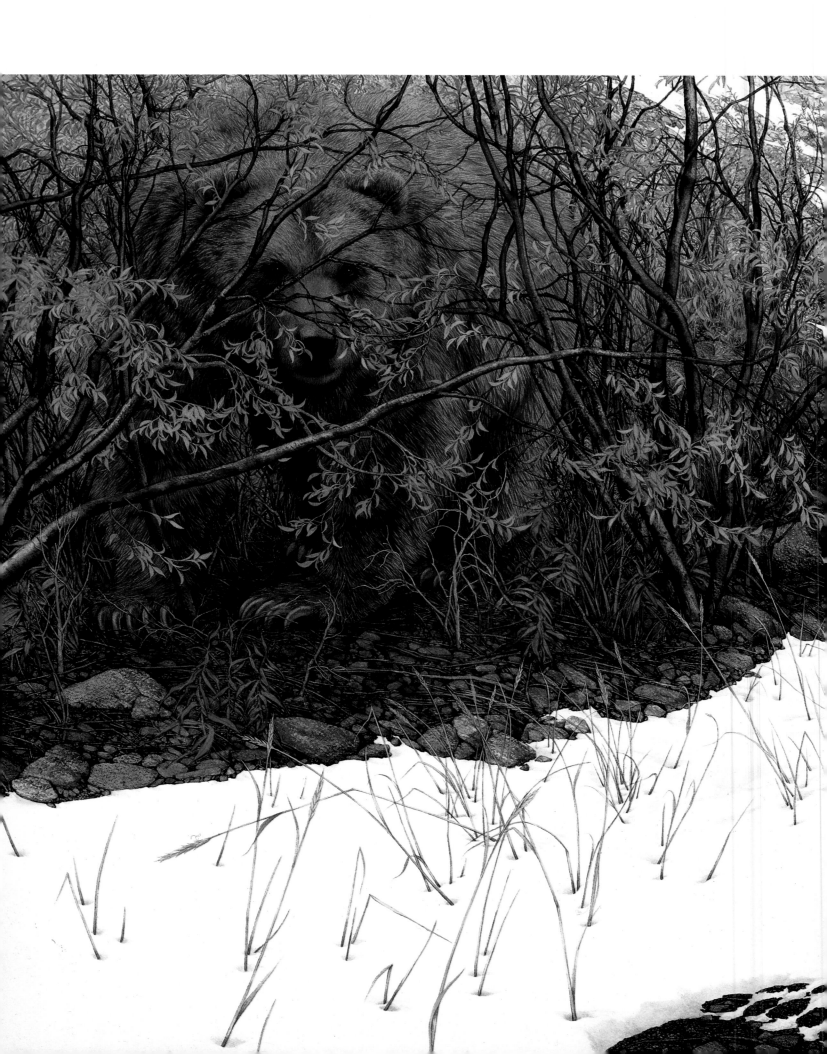

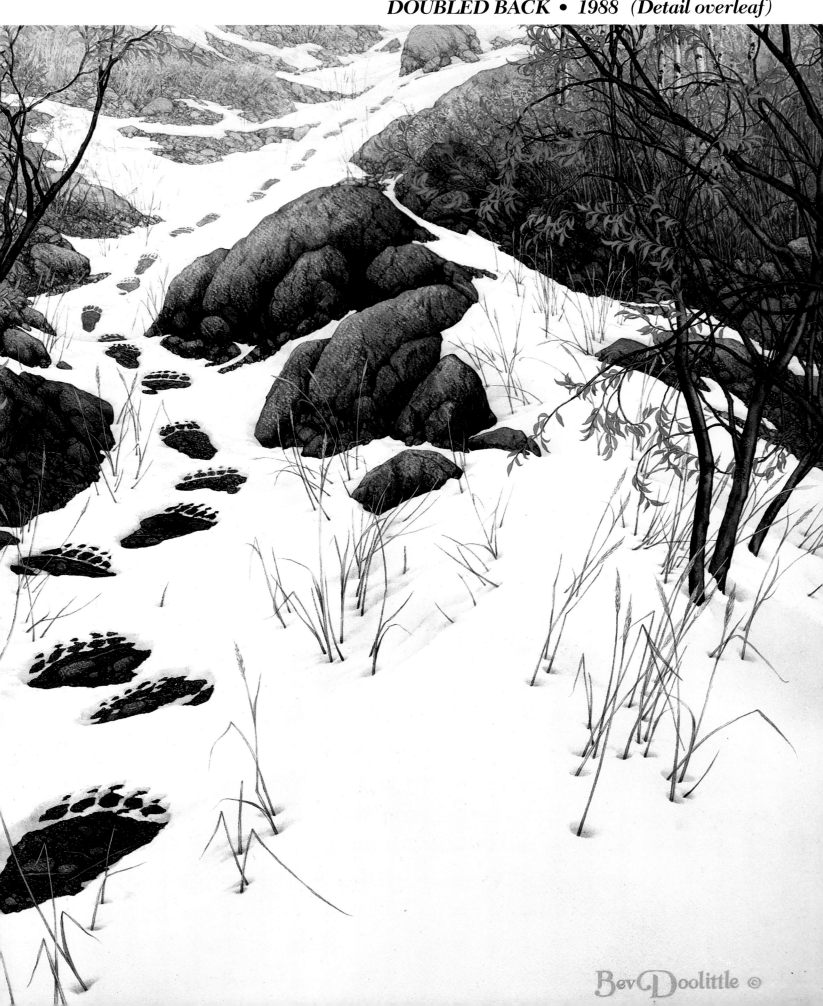

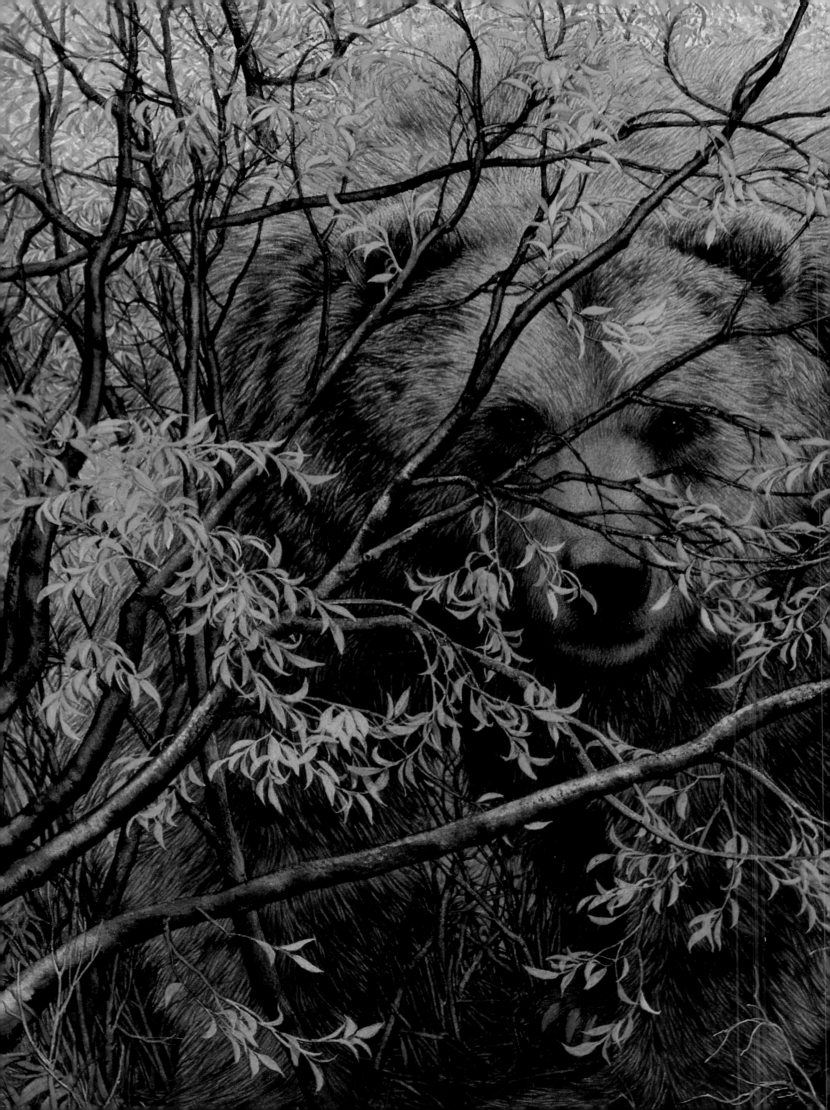

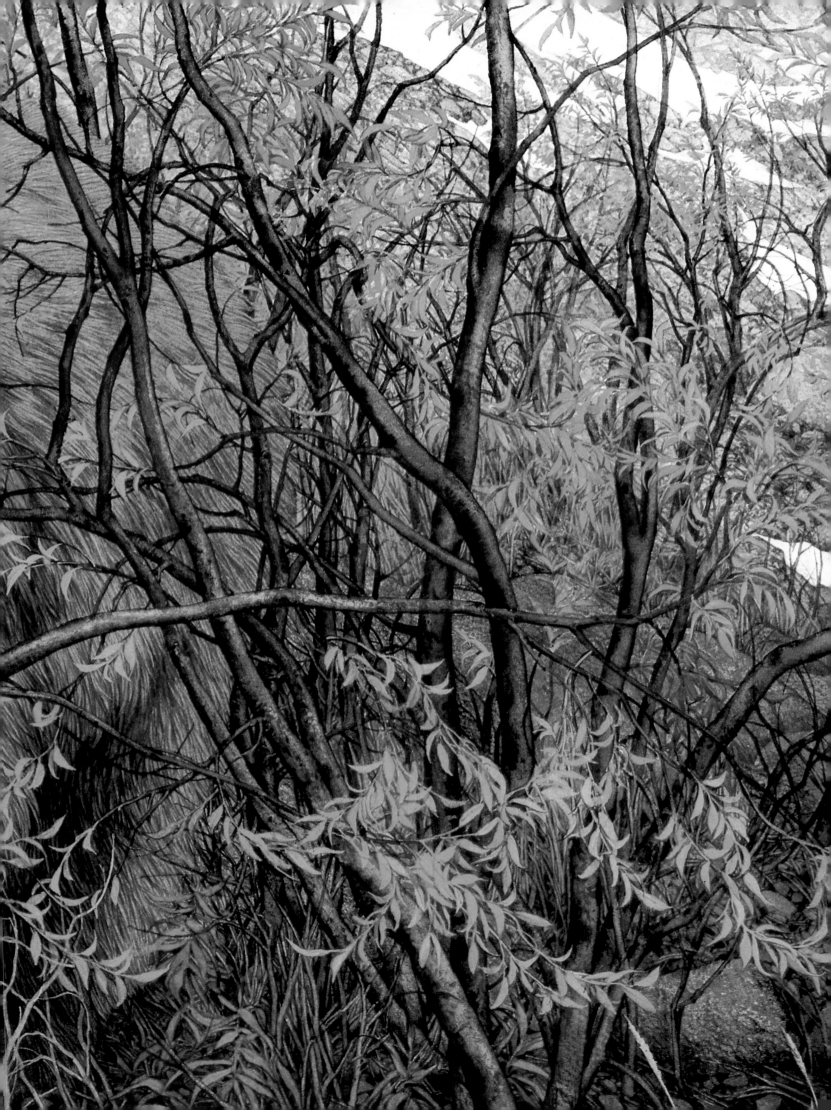

3

A TALE OF TWO TALENTS

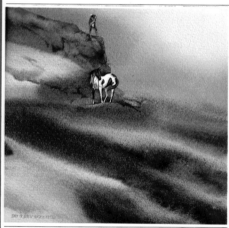

*"...the You and Me's
pulled us back from the
financial brink."*
—Jay Doolittle

Bev Doolittle won her first art award at age fifteen in a contest sponsored by the San Gabriel Historical Society. She became a "working artist" shortly thereafter, selling hand-painted Christmas cards to neighbors who somehow could never bring themselves to send them, preferring to frame them for display on fireplace mantels. Bev's first one–artist show was held when she was fourteen. Her high school art teacher suggested that she apply for the Saturday Scholarship at the Art Center College of Design, now in Pasadena but which was then in Los Angeles. She won the scholarship and began serious art study before graduating from high school.

After graduation she enrolled in the Art Center full time, majoring in advertising illustration because she needed to earn a living while doing her painting. She studied photography, painting, drawing and illustration, and because she was preparing for an advertising career much of her time was spent drawing the human figure and various objects that might one day appear in an ad. But whenever she let her pencil roam, it drew horses, and whenever she could figure out a way she fullfilled an assignment with a horse drawing. For example, when the class was asked to choose a sport, any sport, and illustrate it, Bev chose "the sport of kings"—horse racing. She says, "I immediately rushed down to Santa Anita to talk to the trainers and sketch some of the horses. I watched them work out early in the morning when the sun was coming up and you could see the heat rising up off their coats. It wasn't like school or work; it was like playing hookey." It was also the start of a lifelong habit—turning work into play by involving a horse in the activity.

Bev remembers her teachers at the Art Center as inspiring and encouraging, especially Paul Souza whose landscape painting class she loved. It was in Souza's class that she met Jay Doolittle. Jay had attended public schools in the San Fernando Valley and, like Bev, had always shown a high degree of art ability. His parents encouraged him and at the suggestion of his high school art teacher he, too, enrolled in the Art Center College of Design. He completed two years, worked for a year as a window designer, did a two–year stint in the Army, re–enrolled in the Art Center and graduated with honors in 1967.

Along the way, he says, his philosophy changed. Influenced by the death of a young soldier friend, he became aware of the importance of living in the present. "Prior to this," Jay says, "I was always planning for the future—trips I would take, adventures I would have. Meanwhile all I did was work and save money for school. I decided to do more living in the present."

Jay's new philosophy manifested itself at the time of his discharge from the Army in April of 1966. He planned to return to the Art Center in June but seized the opportunity to "do something" before school started. To Jay, then as now, doing something meant doing something active, out-of-doors, preferably in the wild. Upon this occasion, he took his sixteen–year–old brother on a camping trip to an island off the coast of Mexico. They skin-dived, speared fish, ate seagull eggs and got reacquainted with nature and man's relation to it. Jay determined that he would punctuate his life with similar breaks from civilization.

He returned to the Art Center in June as planned. Also as planned, he took a trip whenever

school was not in session. One week he took a train to San Francisco and rode a bicycle down the coast to Los Angeles. On another holiday he and his brother took a second trip to Mexico. He was beginning to establish a life pattern into which Bev would fit perfectly. But at the time, Jay Doolittle tended to think that girls and wilderness camping were mutually exclusive. In Souza's landscape painting class he met Bev and began to change his mind.

The class habitually painted out–of–doors in a park or at the beach. Bev loved it and, Jay noted, she didn't seem to mind salt spray or wind blown hair. At the end of the semester, as a sort of grand finale, the class was to meet for a weekend painting session at Morro Bay, up the coast toward San Francisco. Bev didn't have transportation and Jay offered to drive her in his parents' station wagon. He was required to meet Bev's mother before she was allowed to go. Passing that test, Bev and Jay drove up Saturday morning and painted in the afternoon.

Bev and Jay Doolittle were engaged a year and a half after they met and married six months after that on June 8, 1968. Jay's proposal was an artistic creation involving a fairy–tale puzzle, a locked heart and a hidden key. Their honeymoon was a painting trip to Zion National Park. Their parents were concerned that Bev and Jay might be competitive in an artistic sense, creating problems in their marriage. That kind of competition never developed. Jay says, "Bev and I are different *kinds* of artists. I majored in advertising design and Bev majored in advertising illustration, but while I rather liked the advertising part—the challenge of finding new ways to present or sell a product—Bev just put up with it. Her heart was always in illustration. Paintings have to be conceived, planned. Creative solutions have to be found. I love that part of the process. Bev is a doer. She loves to draw and paint. She's happiest when she has a pencil or brush in her hand and can make the ideas take shape."

Talk to either Doolittle and it is clear they have a great deal of respect for each other. Bev says she often talks with her husband for months about the concept for one of her paintings, and they do much of the necessary research together. At one point, in their early days of trying to survive as free lance fine artists, they came up with a joint enterprise that would utilize both their talents. At the time, Bev's paintings were becoming increasingly ambitious and detailed which meant that they were taking longer and longer to do, necessitating higher prices than could be commanded at the outdoor art shows which were the Doolittles' only sales outlet. With several shows lined up, they needed to produce good, relatively inexpensive paintings in a hurry. They came up with the idea for what they called "You and Me" paintings. Jay would paint a loose, semi-abstract watercolor background and then Bev would add a small, very detailed animal, Indian or mountain man. Both Doolittles signed the paintings and they sold well.

Bev says, "I love Jay's lovely soft abstracts. They suggest so many things—forests, rocks, sky, foliage. I was intrigued with the idea of leaving much of a painting to the imagination and then giving the viewer a kind of telescopic lens to focus on a particular object shown in sharp detail. It was also great fun pooling our efforts and working as a team."

"More to the point," Jay says, "the You and Me's pulled us back from the financial brink."

WOODLAND ENCOUNTER • 1981

"Woodland Encounter, *painted well along in my career, is a deliberate study in camouflage by misdirection, which grew out of my effort to break all the normal 'rules' of composition.*

The bright-colored fox, dead center, distracts the eye from whatever is going on in the busy snowscape surrounding him. And the richness of design — a wonderful, natural part of the trees themselves — also gave me the opportunity to play games with the traditionally accepted uses of space that govern a well conceived piece of art. . . ." — *Bev Doolittle*

Bev Doolittle ©

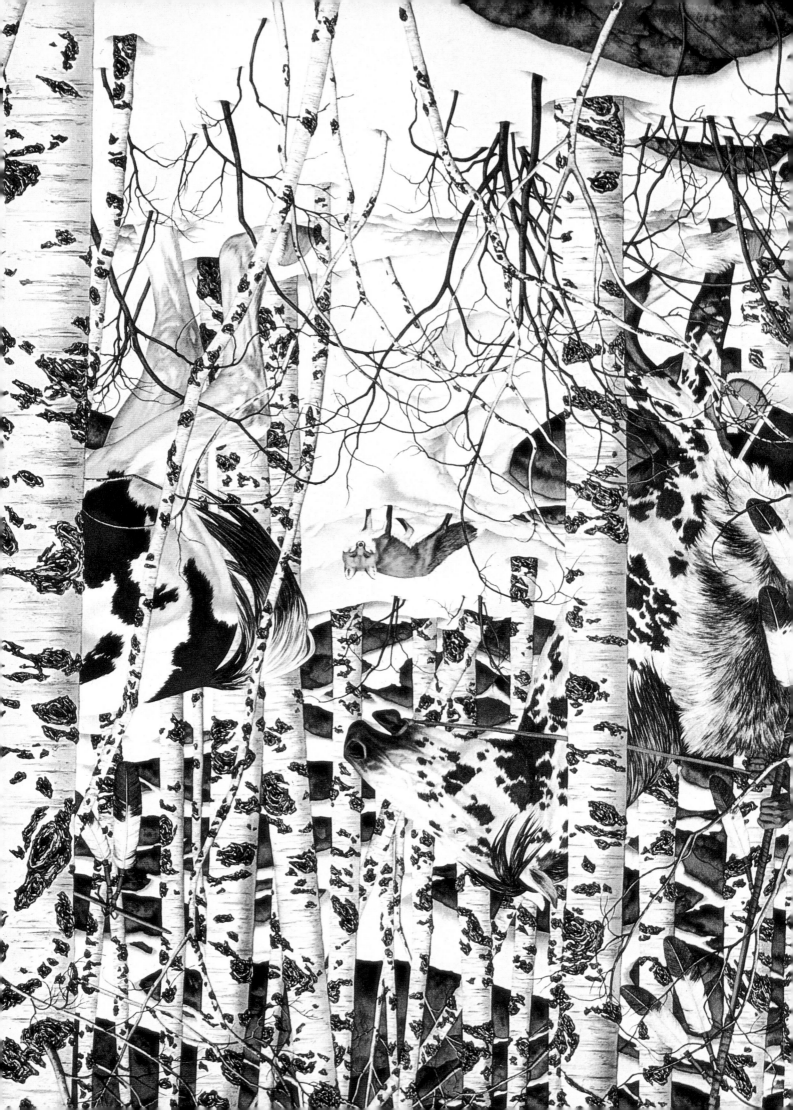

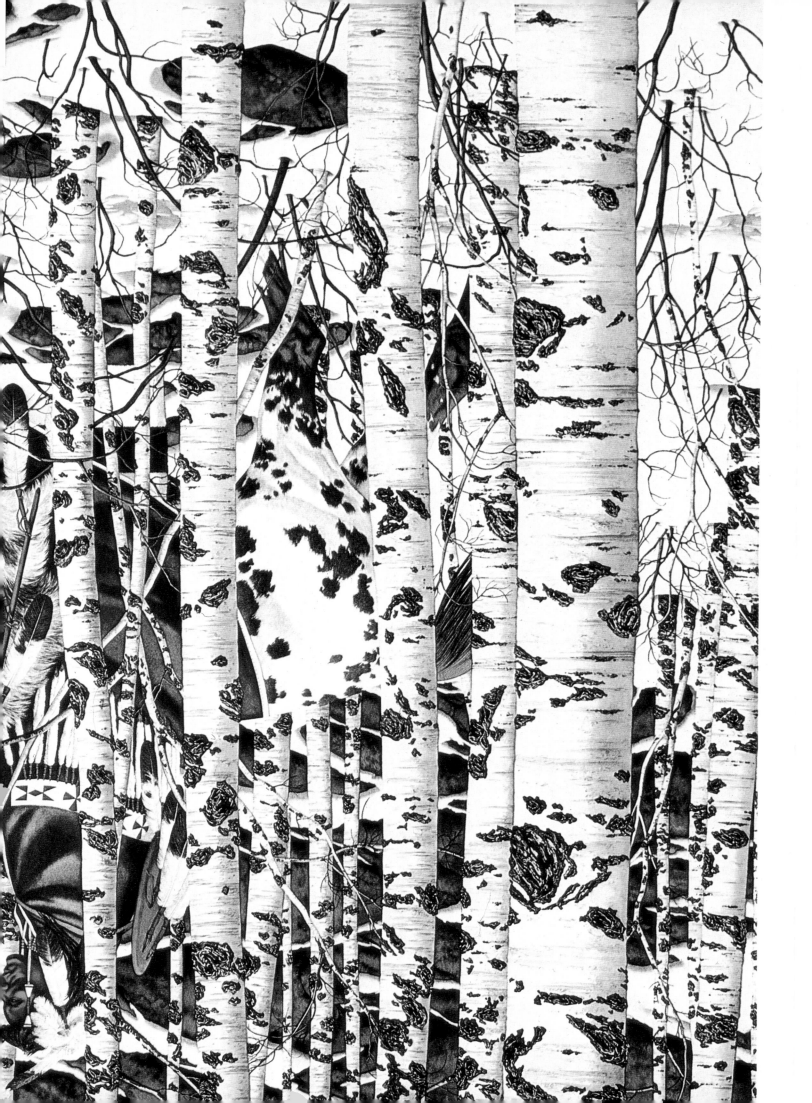

4
MAKING ENDS MEET

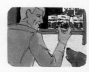

"Jay got to work with beautiful girls in bathing suits and I got the cats and dogs."
—*Bev Doolittle*

Artists must eat and to do so have turned their hands to all manner of paying jobs while they kept on painting. Gauguin pasted railway advertisements for five francs a day. Jay Doolittle took a job in an advertising agency. Bev Doolittle began compiling a portfolio preparatory to seeking work as an illustrator. "Anything in the way of art that would earn a few dollars I would take on, figuring that besides school-work, my portfolio needed something I'd done 'for real.'" For both Doolittles, however, their "real" work continued to be the painting they did "on the side."

In a letter written during this period, Bev tells of doing a series of spot illustrations for the Police Safety League.

> "I quoted $200 and they didn't seem too shocked. The next day they gave more detailed specifications: colored spot drawings, two inches square finished size, approximately four per page; 20 drawings in all for one book and 16 black and white line drawings for the other book. I probably didn't quote enough, but where do I begin price–wise? Also the job has to be done two weeks from today, Thursday, and probably it will be a bit hurried; however it could be a neat little thing for my portfolio. Good news: I finished my big 24" × 48" painting today."

At this point, the Doolittles were living in an apartment in Los Angeles and taking off weekends to ride their bikes on the beach. Once, on vacation, they flew out to Vancouver, B.C., with their bikes and rode all the way back to Los Angeles.

But mostly it was work. For Jay Doolittle at the advertising agency it was often work far into the night. "Finally," Bev says, "I started going up there nights to help him get his work done so he could come home in time for us to have dinner at a decent hour or go to a movie. He's a concept guy, a thinker, as well as a fine artist, but when it comes down to moving a pencil, I'm a lot faster. Together we really got the work done."

Inevitably the Doolittles got caught in this Rumpelstiltskin act. The agency reacted with unexpected wisdom: they hired Bev. Because there was a company policy against hiring husbands and wives, she had to use her maiden name for a time. Eventually, however, the red tape was ironed out and the Doolittles had job security and "probably the lowest pay of any two people there."

Now they were assigned separate projects. According to Bev, "Jay got to work with beautiful girls in bathing suits and I got the cats and dogs." Actually, she confesses, this suited her just fine. Her love for animals had filled her notebooks with photos and sketches. "At the agency," she says, "I had a lot of fun doing some of these story boards and newspaper ads. We'd hire a trainer and he'd bring the cats in and we'd try to get them to eat the product and half the time they weren't hungry. So we'd get a look–alike, a second cat or dog, to eat the

product. We'd keep taking photos until we got what we wanted—for example, until we got the tongue just right."

But the late nights continued and the Doolittles learned that there was no way to avoid them or the tedium of always expressing other people's ideas. Cheerful, industrious, dependable Bev hid her boredom and managed to enjoy her days but she got less and less satisfaction from the results because they were not in any real way her own. She was ready to move on. Disaffection will out, psychiatrists tell us, and what happened next appears to prove them right.

Scene: the advertising agency. Time: late at night. Big presentation tomorrow. Everyone working late. Bev Doolittle is thinking, "I really don't want to work on this project. I want to work on my own. Well, it's pretty much laid out. All I have to do is just get it down." Recalling the incident later, she explains that the copy was to be configured to fit the shape of a bottle. Bev's job was to indicate that fact by "Greeking it in," that is, by filling the space with dummy type that didn't say anything. "I was half asleep," she says, "almost in a daze. If I'd been altogether awake, I'd never have done it, but my hand just started printing things like 'Wine is bad for you because it has alcohol in it that can destroy a person,' and 'I have enough troubles of my own to worry about and I don't need a crutch like booze to add to them.' And this is what got turned in that night."

"The account executive approved it and took it to the client the next morning, and the client approved it and on the plane on the way back the account executive looked at the ad again and all of a sudden he saw what I'd done. He just went pale. He came flying into my office and said, 'Bev, I just can't believe you'd do a thing like this.' Jay, who was sitting next to me, didn't know anything about it and when he saw it he burst out laughing and said the same thing: 'Bev, I don't *believe* you did this.'

"Everyone was in shock. Little Miss Me who would never do a bad thing. I thought, this is it, the end of my job. But when the boss saw it, he thought it was a riot. He still talks about it twenty years later. Well, I didn't lose my job, but I didn't do any more things like that. I call it my first camouflage piece."

Although, as she says, she "didn't do any more things like that," Bev began to think about making a change—not from one job to another but from the world of commercial art to that of free lance artist. Illustrating other people's ideas was not what either Doolittle wanted to do, nor was living in the city. But without financial backing or a huge nest egg, cutting themselves loose from a monthly paycheck was scary. Still, it was becoming clearer and clearer to both of them that if art was worth anything, it was worth everything.

On January 1, 1973, Jay and Bev Doolittle quit their advertising jobs and began their new life as traveling artists.

5
TRAVELING ARTISTS

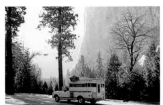

The trip was daring but not impetuous. In a way, it was like one of Bev Doolittle's best paintings—the culmination of a dream, carefully planned, meticulously worked out, and with a very clear purpose. Besides wanting to see the natural world in some of its grandest ramifications—Yosemite, Sequoia National Park, the Grand Canyon, Banff and the Canadian Rockies—the Doolittles meant the journey to be one of inward exploration.

There were things they needed to know about themselves: if they were free to paint every day, would they have the self-discipline to do so? If they were free to paint what they wished, *what* would they paint? And what *kind* of painting would they do, what techniques would they employ if no stylistic constraints were imposed? In short, having learned the ABC's of art, would they have something to say?

On a more mundane level, the trip was to be a year–long experiment to determine whether or not they could make their living as painters. Aside from paint and art materials, they had little interest in material possessions. Their vacation of choice, they felt sure, would always be a camping trip. And the ultimate luxury, it seemed to both of them, would be to have enough time. Time to paint. Time to move on foot through groves of aspen, to camp in deep rock canyons, to touch the remote wildness of the earth with their own hands. They thought that if they were frugal, worked hard and kept their aspirations modest, they might be able to create, for them, the perfect life. They knew they had to try. "I never wanted to be anything but an artist," Bev Doolittle says, saying it all.

With high hopes and open eyes, the Doolittles made their move. They quit their jobs and with the money they had saved they bought a secondhand 1957 Chevy pickup truck, which they fitted out as a camper. It was just big enough for the couple's cookstove, tent, photographic equipment, painting paraphernalia, and bicycles.

"We had to take the bicycles out when we wanted to sleep," Bev says. "On top of the camper we built a small platform so we could paint in the open air out of the way of bears and people. We figured we could also use it as a boxing ring if we wanted to fight."

At last the final "i" was dotted—a sign for the camper. A Doolittle original, the strikingly designed, hand–painted signboard announced triumphantly: TRAVELING ARTISTS. The Doolittles set off.

Grand Canyon. Yosemite. Sequoia National Park. Wonder and awe flooded in. With dozens of exciting images and ideas crowding her mind's eye, Bev could scarcely paint fast enough —although in those days her style was very loose and fluid. "Back then," she says, "I would do two or three paintings a day. Now I do two or three a year."

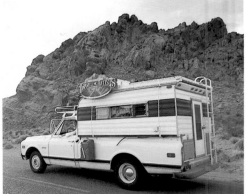

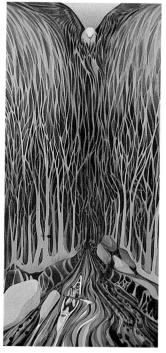

She painted the Grand Canyon from the top of the camper, in a style very different from the way she paints now. She painted a small reflecting pool in Yosemite and sold it on the spot for $15. The traveling artists were in business.

Bev's first order of business was to allow herself to develop as a painter. If someone came along, liked a painting and wanted to buy it, Bev would sell it, but she was never tempted to duplicate it or emulate it. Free for the first time to take an idea and play with it in her own way, she excitedly did just that. Ideas crowded in and as she attempted to work them out, Bev's paintings gradually evolved from straightforward landscape to the multi-layering of design, narrative and inner meaning that characterizes her work today.

For example, a charcoal sketch of an Indian in a canoe became a liquid impressionistic watercolor. Then as she became more and more intimate with lakes and rivers, she redid the painting, concentrating now on reflections in the water. Realistic but with a strong design element, the painting is striking and many watercolorists would have been satisfied with it. But Bev, wanting to take the idea still farther, reworked it again, adding a powerful sense of myth and mystery that transform the painting from illustration to fine art.

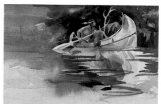

Although the Doolittles had constructed their "boxing ring" to minimize intrusion, they discovered that they enjoyed and learned from people they met along the way. Since their way took them into wilderness areas, they met many like-minded folk who shared their enthusiasm for wildlife and the out-of-doors. "Through the years, we've kept in touch with quite a few of the people we met on our travels," Bev says.

Still, the experiences that were most significant for her artistically were first person encounters with hills and lakes, trees and flowers, birds and animals. Although remote wilderness areas and hard-to-find animals in the wild inspired her, she was also able to see artistic possibilities in incidents and scenes many people would dismiss as too ordinary. A squirrel that practically sat in her lap while he ate half a box of Ritz crackers gave rise to a series of sketches and finally ended up in a painting that marked her first researched effort to imagine and project what life must have been like for the American Indian.

Even a touristy little drive-in campground complete with picnic benches had something to offer. Here, Bev experienced "an incredible sense of discovery. We had set up camp and were walking about when we noticed a boulder with mortar holes hollowed into it. Looking around on the ground, Jay found two obsidian arrowheads, translucent, in perfect condition. We also found quite a few broken arrowheads. We realized that the area had been an Indian encampment. Indian women had used these mortar holes to grind acorns into meal. The arrowhead we held in our hands had felt the touch of Indian hands."

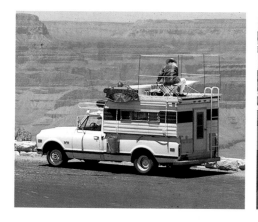

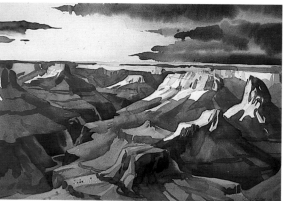

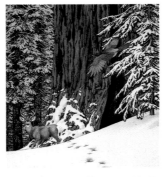

For the first time, Bev Doolittle says, she felt an Indian presence. Immediately she wanted to know more. In gift shops and bookstores she bought everything she could find relating to the daily life of the Indians who had inhabited the area. At this point, she was primarily interested in what the Indians ate and wore, what tools they used. Her fascination with Indian myth and mysticism would come later. But already she felt linked in some indefinable way to these ancient people whose empathy with the natural world was so like her own.

Practical as ever, she read, took notes, sketched. She learned what kind of acorns the Indians used, what their baskets looked like. And then, she found herself starting to smile. She remembered her pilfering squirrel and imagined that an Indian woman grinding acorns might have been pestered by just such a cunning marauder. So she painted the scene.

In Sequoia National Park, wandering among giant 3000–year–old trees, some over 300 feet with their lowest branches a hundred feet above the forest floor, Bev Doolittle's brush again paused in awe. She imagined how the white man must have felt entering a sequoia forest for the first time. She was fascinated with the huge hollowed out tree trunk caves characteristic of the species. How many creatures might seek refuge from the elements inside one of these great trees? She painted a study of a scene around the tree and called it *Broken Silence.*

Years later when The Greenwich Workshop asked her to create a Christmas print, Doolittle thought of the red bark, the green needles, the white snow and the glow of firelight. She painted the mountain man celebrating Christmas in the heart of a sequoia tree. Alone, he would be safe and warm and thinking of home. He might deck a tiny Christmas tree with whatever he had with him—a watch, a feather, a locket enclosing a curl of a sweetheart's hair. He might even build a fire and roast a little bird. Of course, among these forest giants so old that time had almost no meaning, the man would not be sure what day or even what week it was. So she called the painting: *Christmas Day, Give or Take a Week.*

From Banff, high in the Canadian Rockies, a long road rises straight up 170 miles to Jasper. The Doolittles were now halfway into their trip, photographing, sketching, taking notes. Bev, struck by "the power and wildness of the place, the sheer immensity that leaves you breathless," goes on to say, "If you are an artist, you have to try to get that feeling of largeness on paper."

Soon they found themselves high in summer snow country where everything is startlingly defined. White snow outlining every dark ridge and hollow. Deep shadows. Hard edges. "Patterns," Doolittle says, "I started getting very excited about patterns." She painted *Winterwolf* at about this time. It differs from many of her other paintings in that it is not concerned with details. At the same time, it is altogether realistic. "Everything up there looks much more graphic because of the sharp contrasts of light and dark. In nature there are so many textures but snow is like an eraser, shaving everything clean, getting rid of all the

busyness. It's as though the details are whited out and what's left has a suddenness about it, a clarity."

In Canada, the Doolittles did a lot of hiking, moving up from the valley close to one of the great glaciers between Banff and Jasper. They were looking for mountain goats and they found them. The goats were shy and fast but by using a long lens, Bev got many photographs and made many sketches for future paintings.

"You can never get too many photographs of animals," she says. "They twist and turn and climb. Even with horses, which I know so well, I still take pictures. You can't remember all the different things that sunshine and shadow does to moving forms."

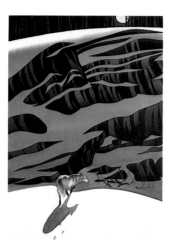

Coming upon a goat and a kid, Bev was reminded of a story that a bush pilot had told her. He said he had seen an eagle swoop down and snatch a baby goat off the edge of a cliff. The mother goat was standing nearby but in an instant the eagle was high in the sky and there was nothing she could do. "I wanted to do a painting of this," Bev says, "but I didn't want to show the ending. Actually, I wanted to paint the question: does the eagle get the baby goat or not? I tried to stage the three elements—nanny, kid and eagle—in such a way as to leave the ending unresolved so that the viewer could make up his or her own ending."

In the finished work, the artist's interest in patterns and composition is evident but a narrative quality has been incorporated. In her painting she was beginning to do several things at once. "I would do it very differently today," Doolittle says. "But I was learning a lot—about painting and about people." Viewers, Doolittle discovered, were almost equally divided when it came to predicting the kid's fate. Some, among them quite a few hunters, said, "The kid's had it!" Others, optimists and wishful thinkers no doubt, staunchly insisted that the mother goat would have scared the eagle away.

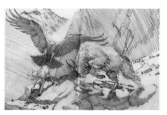

With so much territory to explore, so much to see and do, another artist might have been tempted to defer stylistic experimentation to another time. But Doolittle never regarded technique as static, something to be repeated or copied. In fact, she saw in this trip a welcome opportunity to distance herself from even the subliminal influence of other artists—an influence, she thinks, that might have been responsible for a period during which she could never seem to get her paintings *realistic* enough.

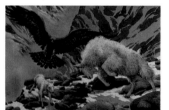

"I finally realized," she says, "that my paintings would never be photographic—and I didn't want them to be. I wanted them to be detailed and accurate but true to an inner image the camera doesn't always catch." To find that image, she tried beginning with an abstract and bringing up evocative areas of shapes. With this technique, she provided a rock-bound setting for a moose she had photographed in a boggy meadow—turning the female into a bull moose with antlers in the process. The artist left certain areas as abstract because, she says, "I wanted to retain a sense of mystery."

Later Doolittle was to perfect and refine this technique and utilize it in mature works expressing the mystical aspects of Plains Indians' culture.

BROKEN SILENCE • 1975

"Sequoias and aspens are among my favorite trees — so different in feeling and stature that it's amazing to think they belong to the same family.

A sequoia forest is deep and quiet. Here the silence has been disturbed, the deer alerted by the flight-racket of the Steller's jay."

— Bev Doolittle

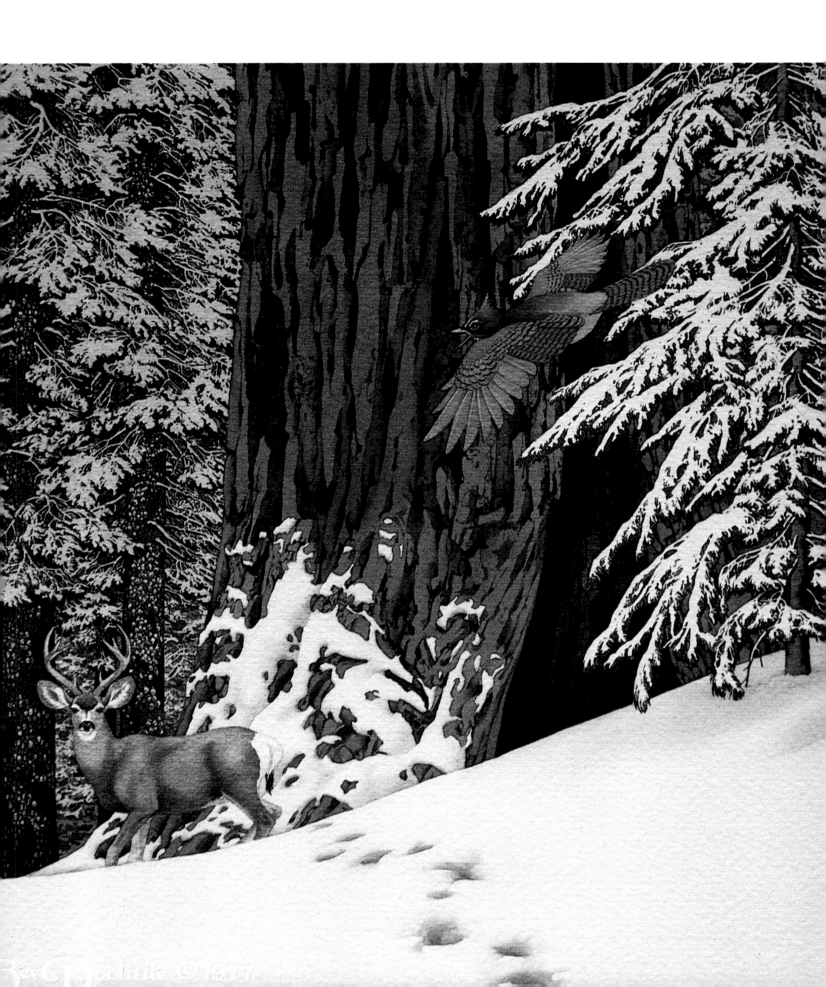

CHRISTMAS DAY, GIVE
OR TAKE A WEEK • 1983

A Mountain Man's Christmas

Only my footsteps in the snow,
Only the glow of my fire,
Only a choir of wind to sing the benediction.
But I feast on memories
In a holy place.
It has been so long since I have heard my own voice
It startles me
When I say the grace.
May all things lost, apart, alone
Find some small shelter of their own.

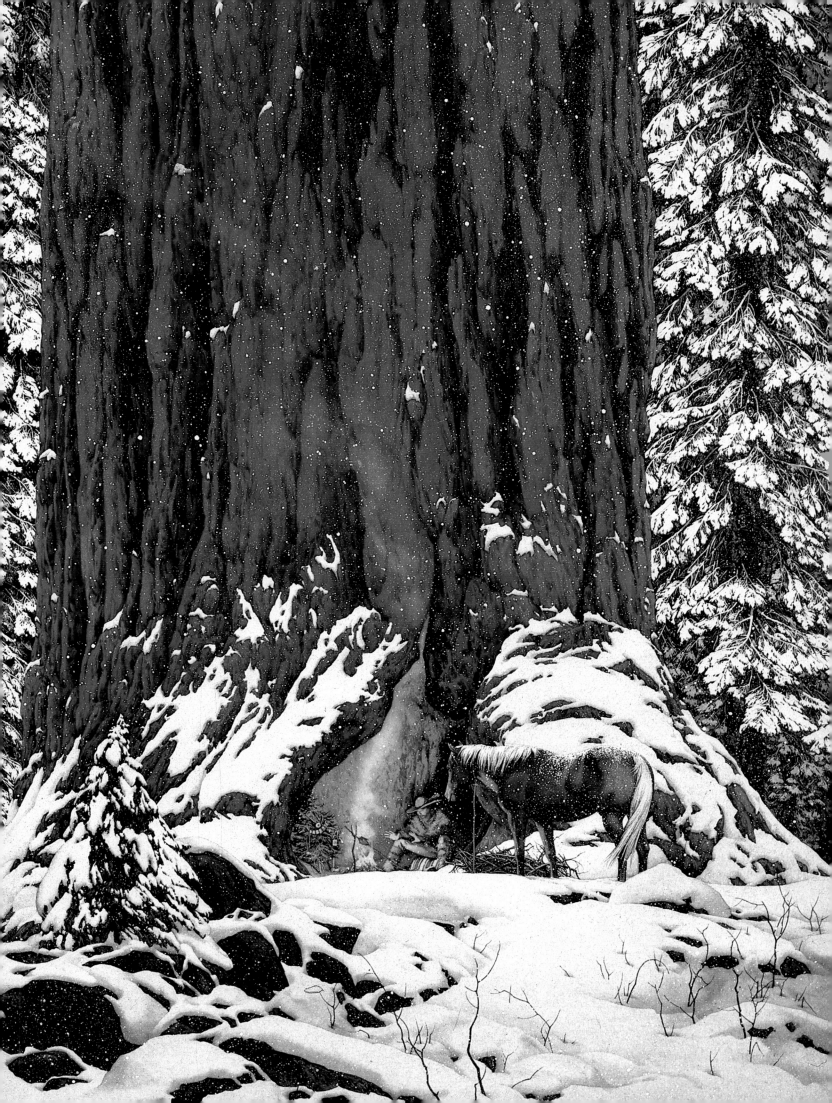

CHRISTMAS DAY, GIVE
OR TAKE A WEEK *(Detail)*

"With typical resourcefulness the mountain man has found shelter, peace and warmth. He has unloaded his horse, gathered wood, made a fire and rigged a makeshift cooking stick for his meal of a local game bird.

The great sequoia will take no harm from the small, cheerful blaze. If it gets really cold, he'll likely bring his horse right into the shelter of the tree-cave for the added comfort and warmth to both of them." — Bev Doolittle

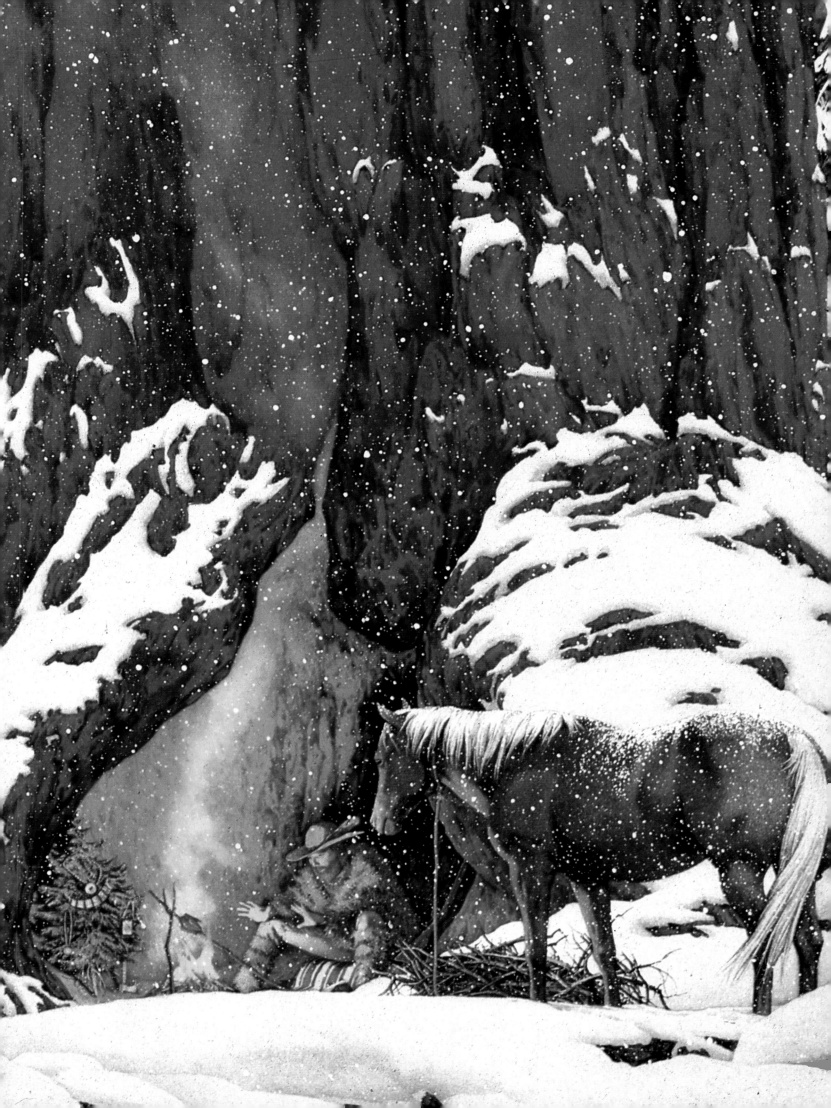

WINTERWOLF • 1973

"This was pure abstraction, drawn from the great, thrusting mountains of the Canadian Rockies. I deliberately simplified everything down to the basics, trying to work out patterns of space and non-space in the context of a season and a terrain that endlessly lend themselves to the magnificent designs etched by nature." — Bev Doolittle

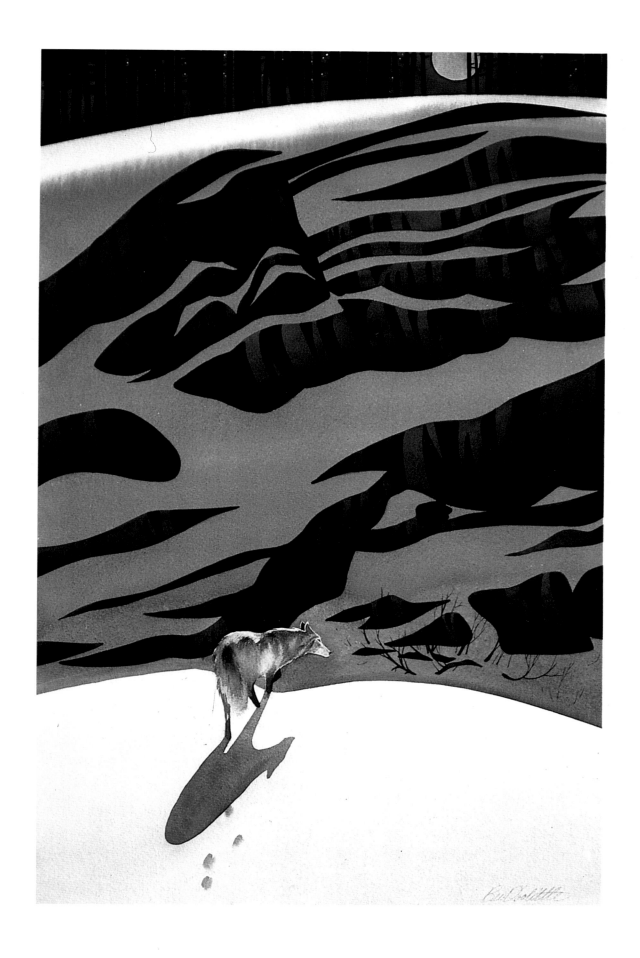

DAWN REFLECTIONS
1975

"Some of the early paintings I like better than others, perhaps because I felt at the time that I had worked out a goal I'd set for myself. This Indian in a birchbark canoe is one that was a kind of marking point for me."
— *Bev Doolittle*

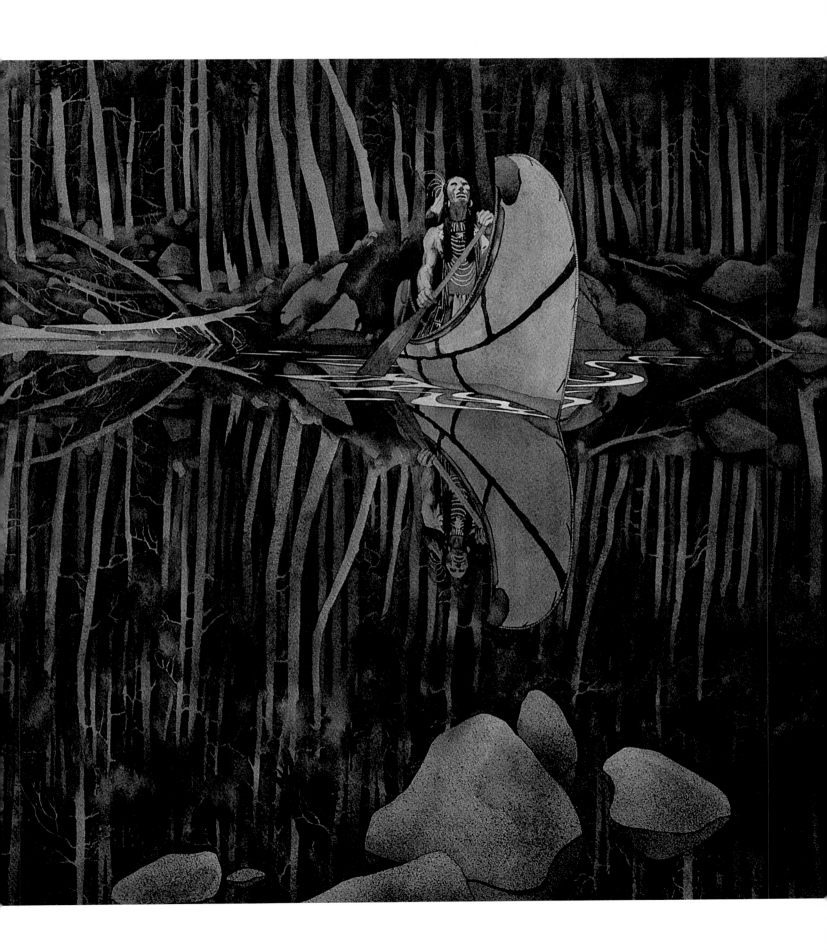

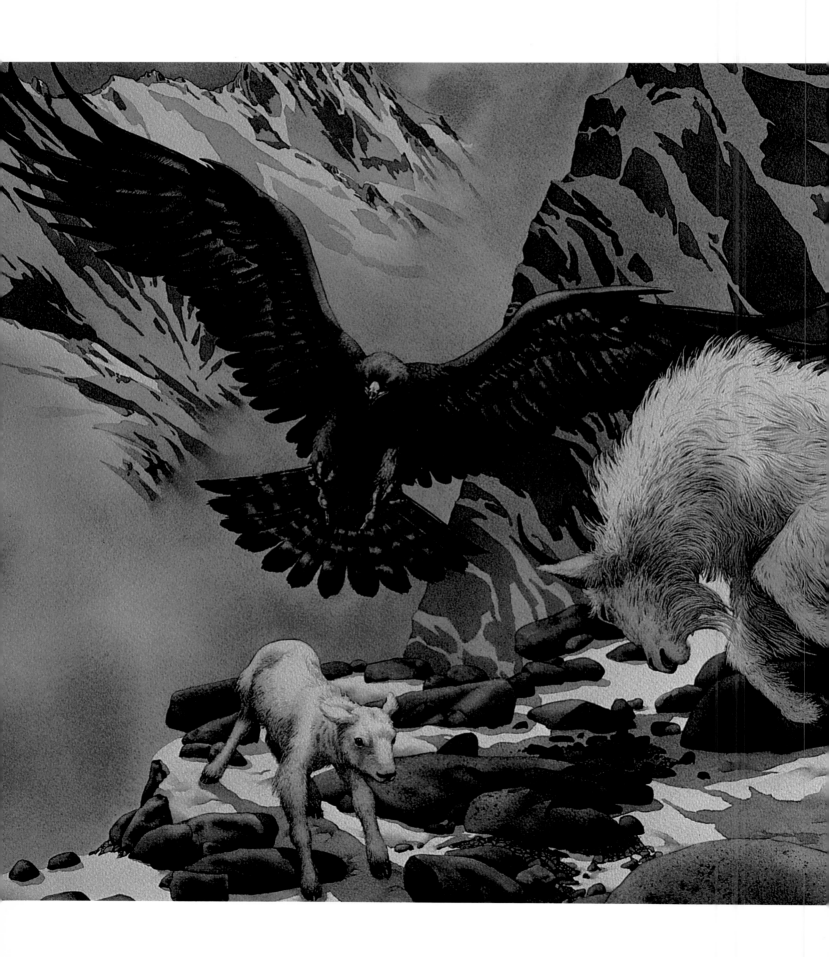

TALONS AND HORNS • 1976

"This one took a lot of working out. The young of mountain goats and sheep are logical prey for the big raptors but of course the great birds can't always be successful. The nanny is a fierce defender of her kid so I like to think that in this encounter the issue is at least in doubt."

— *Bev Doolittle*

ALPINE DRIFTERS • 1973

*"Up in Jasper on one of our trips my husband
and I came across some ewes and lambs —
mountain sheep. I was still into shapes rather
than detail so the painting I did is a little
loose, a little abstract in the background. But
in fact the rocks themselves, those fissures
and crags, are like gigantic abstract sculp-
ture. I incorporated very realistic subject
matter as a contrast to the background."*
— *Bev Doolittle*

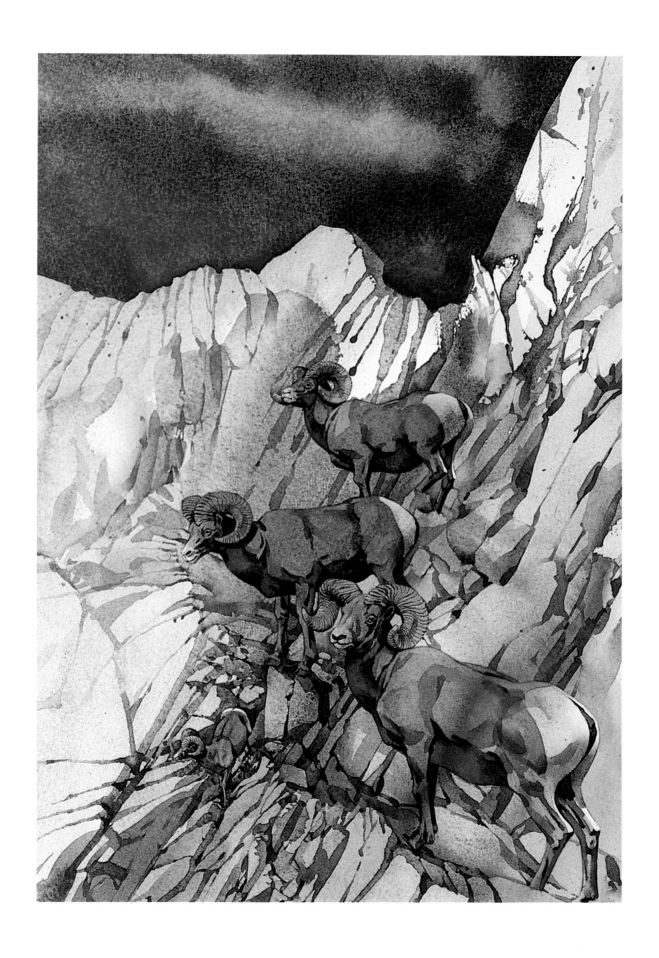

AUTUMN SOLITUDE
1977

"I started with an abstract painting, very loose, and then just found an area in which to put that animal. It was a stage I worked through, really experimenting with the patterns and the shapes and just the gushy things that happen with watercolor."
— Bev Doolittle

TWO BEARS OF THE BLACKFEET • 1986

"The technique of focusing on a firm image to make it jump from an abstract setting — which Jay and I had also used with the You and Me's — stayed with me. Years later, it became one of the approaches I would utilize in interpreting the spiritual expression of Indian belief.

Like many other tribes, the Blackfoot relied for protection and strength on the spirit powers of wild creatures, as well as sky spirits such as the sun, wind, rain and thunder. A warrior might achieve a vision of his own totem by prolonged fasting and prayer. Here, I chose to clearly define Two Bears, whose name announces the power of his spirit-totem, against the loose image of his personal vision."
— Bev Doolittle

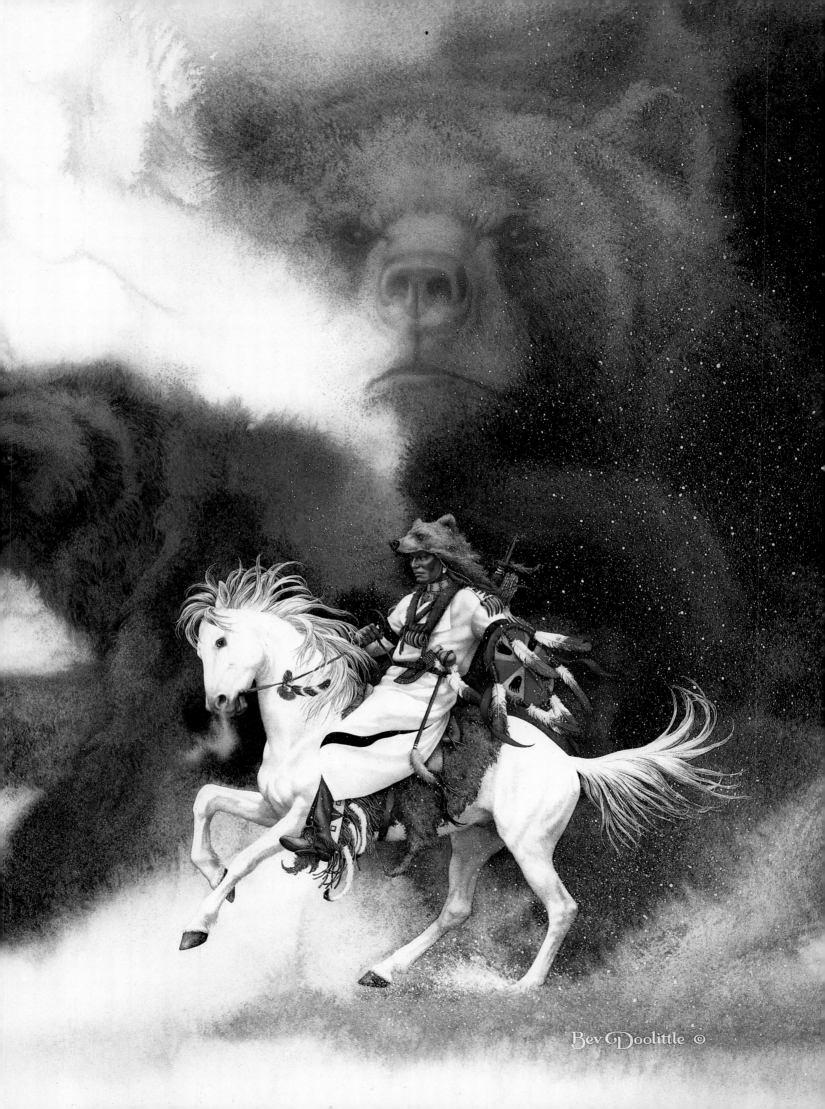

6
THE ROAD TAKEN

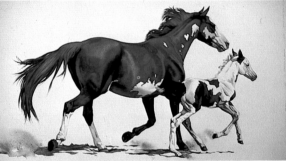

"Two roads diverged in a wood, and I—
I took the one less traveled by,
And that has made all the difference."
—Robert Frost

Their year of travel flew by and it became time for Bev and Jay Doolittle to decide whether to return to paid jobs in commercial art or to try to survive on their own as fine artists. They had expected the "Big Trip," as they called it, to provide the answer. It did in one respect. They *had* painted. Without assignment or deadline they had been unbelievably productive, returning home with dozens of finished paintings, sketches, color studies, photographs and painting ideas. On the other hand, they had not made much money. Well, they reasoned, they had not been thinking a lot about making money. It was time to put their minds to that.

Researching a subject had become their habit so Jay acquired a copy of *The Art Marketing Handbook*, by Calvin J. Goodman, and was attracted to some of its suggestions, especially the idea of art–sales parties. He and Bev tried to arrange such parties, modeled roughly on the Tupperware home party. This worked to a degree but the success of this type of venture depends on persuading an ever expanding number of people to host parties and act as sales agents. Neither Bev nor Jay were interested in empire–building. An ad seeking an agent who would line up sales parties brought disappointing results. The low point came when an art party was arranged and *no one* came.

"On the way home," Jay Doolittle says, "we started seriously discussing other selling options." Remembering an annual art show held in the courtyard of the Pasadena City Hall, the Doolittles contacted the organizers and entered their first outdoor art fair. It was a huge success. They sold forty paintings and made seven hundred dollars. They were elated. Jay says, "We thought we were rich. $700 in one day! Then we realized how long it had taken to paint those forty paintings." Bev says, "I call this our starving artist period because some-times weeks would go by without a sale."

Still, the "starving artists" had found a way to sell their paintings and began seeking outdoor art shows, fairs and festivals to enter. They were especially successful in places like Lake Tahoe, Mammoth Mountain, Big Bear Lake and Palm Desert.

Going farther afield, they read about a prestigious outdoor show in Austin, Texas, and decided to give it a try. On the three–day drive to Austin they worried about whether the show would produce enough to offset expenses. The show was held on the beautiful tree–shaded grounds of the art museum next to the river. There was a big, invitation–only Friday night preview and then, on Saturday, the show would open to the general public. At the preview the Doolittles did not sell a single painting. They felt like going home. The next day, they sold almost every painting they had brought including a ruffed grouse with an Indian in the background—Bev's first real camouflage painting. With much trepidation, they priced this at $2000. They were so excited and nervous about this foray into high finance that they insisted on hand–delivering the painting only after they had cashed the check and had the money in hand.

Although it was time consuming, Bev and Jay found that they enjoyed following the outdoor art show circuit, especially talking to the people who came to look and buy.

"Sometimes people saw things in my pictures that I didn't see," Bev says. "Other times they reacted exactly as I expected which made me feel good, too." When a young waitress bought a small painting on a lay–away plan, paying only $10 a month, Bev was deeply touched. As art consultant Calvin Goodman points out, "The working professional artist who reaches out to the public profits from the experience in ways that are only indirectly related to money."

But making money remained a problem. The Doolittles attacked it with hard work and inventiveness. Four charcoal drawings of animals Bev had done in Yosemite were converted into prints which the Doolittles offered for $5 apiece. Almost 500 of these prints were sold.

"The raccoon and the eagle were our bestsellers," Bev says. But she did not rush to populate her paintings with raccoons and eagles. Years later she created several beautiful eagle paintings, inspired not by the promptings of a ready market but by the discovery that her feeling for the powerful bird was one of admiration and awe—much like that of the American Indian.

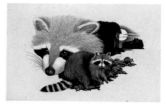

At this point, Bev and Jay were living in a 22–foot trailer in the backyard of Jay's parents' house in Van Nuys. It sounds grim, but they didn't see it that way. Bev says, "It was a fun time. We parked way back in a grove of walnut trees. We had a campfire every night. We painted every day."

For inspiration Bev drew on her memories of the Big Trip, the dozens of sketches they had made and hundreds of photos they had taken. Later she would use these elements in more complex ways but back then she says, "I was fascinated with the patterns and designs that occur naturally—tree trunks, reflections, the ripples swimming geese make on the water."

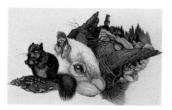

A beach scene painted during that period spotlights an abstract design created by the tide along the Oregon coast. "I was really involved with shapes and how they relate to one another. When the tide went out it created a kind of bas relief in the sand."

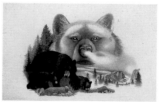

In Banff Bev had seen and photographed elk in the snow. She painted them now, not in detail as she would paint animals later, but emphasizing the design element. The result reminds one of Japanese screen painting, with a great snowfield in the foreground, the antlers of a buck darkly outlined against it, and the color scheme reversed in the background where antler–like tree branches are white against a dark forest.

Soon Doolittle began adding imagined elements to the real scenes she had photographed or sketched. These imagined elements were always carefully researched. For example, the Indian tepees hovering on the edge of a snowscene are Plains Indians' shelters carefully researched for authenticity. One of the delights of Doolittle's painting then and now is involved with the realization that however whimsical or romantic the scene, it *could* have happened.

Although Doolittle's research takes her to museums and libraries, much of what she needs is in her own photographic archives. She takes hundreds of photographs—wide angle distance shots and intense close-ups because she needs to know both the general and the particular—what an aspen grove looks like, how the leaves attach to the branches, the pattern of veins on a single leaf. Books and other people's photographs are less helpful because, Bev says, "Only I know what I'm likely to want to paint."

For example, her painting, *Bugged Bear*, grew out of her photo of a bug on a flower. "I knew one day I was going to use this in a painting," she says, laughing at the extent to which she ultimately elaborated on the idea. For the artist, the painting presented a technical problem which she solved by the use of forced perspective. It also entailed additional research to be sure that no "foreign" flowers cropped up in the composed landscape. Viewers, however, simply took the painting to heart. As recently as 1989, a fan wrote, "That darned bear looks the way I felt when the taxes were paid…I just flat out chuckle every time I look at the expression on that face because it is so delightful."

Doolittle herself confesses that she gets a laugh out of painting animals in whimsical situations. The painting she calls *Whoo!* is a case in point.

Photographing cottonwoods for information, Bev discovered a great horned owl hiding in the branches. It's hard to imagine anyone but Bev Doolittle coming up with the amusing scenario she painted. In the finished painting, a beaver has just chomped through the tree trunk and the owl is about to have a rude awakening. Since beavers are busy by day while owls are nocturnal, Bev could be right when she says, "I'm sure it could have happened some time somewhere in the wild."

Around this time Bev got her first painting commission. She was to paint a Cossack. Because she had no clear idea of what this Cossack should be doing and the buyer had no suggestions, she painted the czarist cavalryman on a horse coming down a very steep mountain trail—a dramatic pose and a difficult one. Thriving on challenge, she began, as she always does, with rough sketches, drawing the rider nude to be sure not to lose the correct body movement in folds of clothing. She knew enough anatomy not to need a live model although later, because it was quicker and easier to have one, she often enlisted the services of her obliging husband.

The client was happy with his painting but Bev kept seeing the Cossack as a mountain man. Finally, she redid the painting, showing the mountain man as she envisioned him, pulling a frightened packhorse behind as his own steed gallops flat out to escape unknown (and perhaps imagined) attackers. This painting, titled *Pursued*, is one of Bev Doolittle's first mystical paintings.

This sense that there may be more than can be seen stayed with Doolittle, and through the years she handled the concept in her paintings in many ways. Usually she hinted at what the unseen might be, but in a later work, a strong mood piece called *Unknown Presence*, she leaves it totally up to the viewer's imagination.

Free to paint what she wanted, Bev sometimes indulged in what was, for her, relaxation—painting horses, painting them just because they were beautiful; no meaning, no message. Still, even these straightforward portraits reflect this artist's amused view of the world, a world where the eye of the horse is on the blackbird, mares act coltish, and an obstreperous stallion objects to even the handsomest Indian blanket.

Although it was easier to sell small, loosely painted watercolors that Bev could complete in a few hours and price at an affordable sum, she was doing fewer and fewer of these. She had found her voice as a painter, had a lot to say and had learned that she must say it in her own unique way. At the same time, there were painters she admired, among them Frederic Remington. When she got a commission to do a painting "like Remington" she thought it would be interesting to try. The client wanted something with a lot of action, a lot of fighting, maybe an Apache battle. To Bev, that meant horses in every position, plunging and

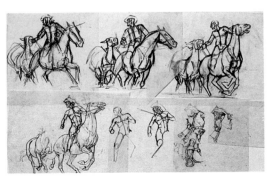
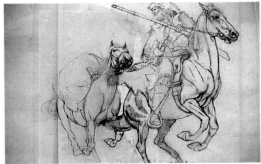

rearing and galloping flat out. That sounded like fun. It wasn't. Her heart wasn't in the fighting and she missed having a vision of her own to express. She also missed her watercolors (she was doing this painting with acrylics). While many people feel that transparent watercolor is a devilishly difficult medium, Bev is totally at home in it.

She finished the painting to her own and her client's satisfaction, but she says, "I vowed I would never again try to paint *like* anyone except Bev Doolittle."

By now that meant large, complex, highly detailed paintings which required weeks, even months of planning, research, drawing and painting. While her art was inviolate, Doolittle decided that the economics would have to be redrafted.

She began keeping time sheets and pricing her paintings according to the amount of time it took her to do them. In terms of dollars per hour, she might have done better working as a waitress. At the same time, a $2000 price tag on a watercolor displayed in a parking lot was unheard of. Because, as she puts it, "I pretty much priced myself off the street," the Doolittles began looking for a gallery to sell Bev's high–priced works.

They also began looking for a way to escape from the city. They found it in Joshua Tree, a small community 140 miles east of Los Angeles near a desert wildlife preserve encompassing half–a–million acres. In Joshua Tree, the Doolittles discovered that they could rent a three–bedroom house for the price of their one–bedroom apartment in Woodland Hills. Infatuated with mountains, they had not thought much about the desert and secretly considered it a temporary solution to their housing needs.

The desert had other ideas, greeting the newly arrived artists with a spectacular summer thunderstorm—an awesome experience in this area of twisted rock and tumbled heaps of boulders where thunderheads pile up in towering masses and the breeze is pungent with the smell of greasewoods before the rain. "We began to see that the desert could be an exciting place," Jay says. Winter confirmed that idea with an early snowfall, and by spring the Doolittles had learned that the desert has many secrets to share with those who will take the time to see.

The desert also offered the privacy and solitude they needed to work; it enabled them to live a healthy, outdoor life, and it provided inspiration and subject matter to paint. They had found a home.

Their search for an art gallery to handle Bev's higher priced work was equally felicitous. At an outdoor art show in Death Valley, Bev heard about the Carson Gallery in Denver, Colorado. They contacted this gallery and, by the late 1970's, Carson was selling all the paintings Bev could produce at higher prices than she could command at outdoor shows. This meant that she could stop traveling from show to show and spend more time on art.

In 1979 Bev Doolittle completed the painting called *Pintos*.

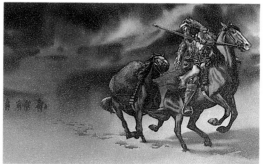

SURPRISE ENCOUNTER • 1976

*"The ruffed grouse is a very brave little bird,
and cunning too. Virtually invisible among
the grasses where they feed and nest, at the
approach of a threat, parent birds will awk-
wardly flutter off, deliberately attracting
attention and even pretending injury in order
to draw predators away from the young. The
grouse in the painting is also the object that
attracts one's immediate attention, but what
I am misdirecting here is the eye of the
viewer (perhaps) from the predator in the
background!"* — Bev Doolittle

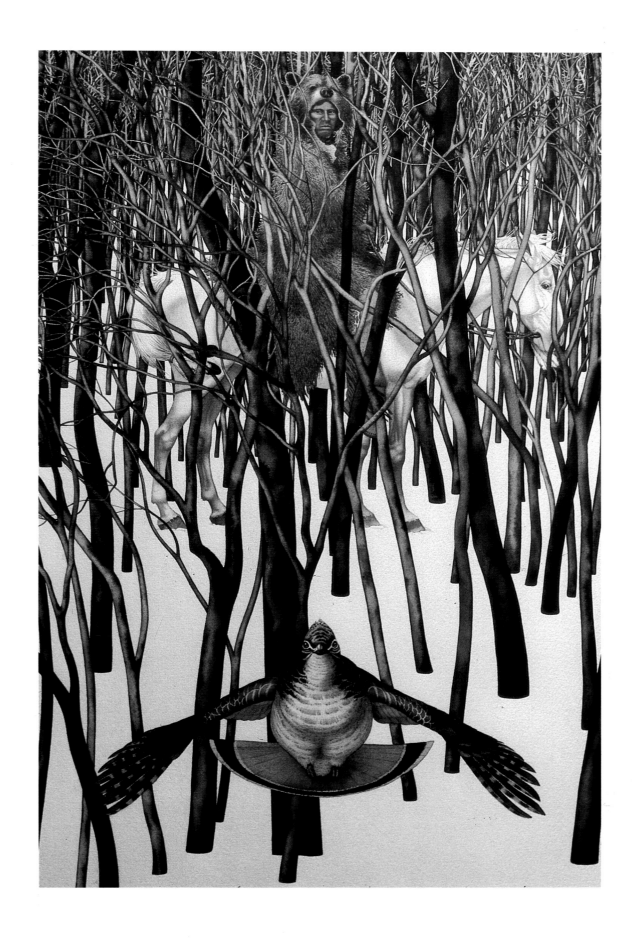

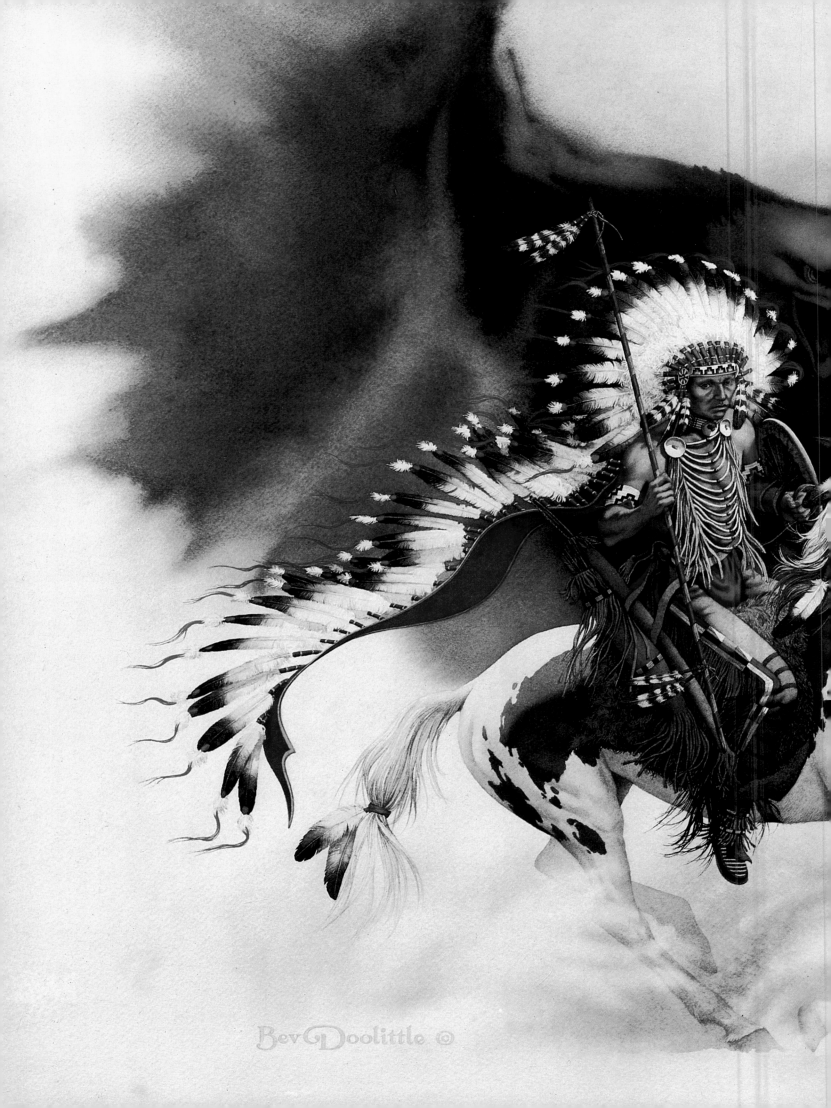

Bev Doolittle ©

RUSHING WAR EAGLE • 1983

SMOOTH RIDE • 1973

*"The Canadian geese in this subject are really
only an excuse for trying out a combination of
the loose, soft effects you can get with water-
color, combined with a simplified pattern of
reflections from the movement of the birds
and the tree design in the background.*

*Maybe I was also trying for that incredibly
smooth, liquid glide of big waterbirds, even
though their webbed feet are working away
powerfully to move them along."*

— *Bev Doolittle*

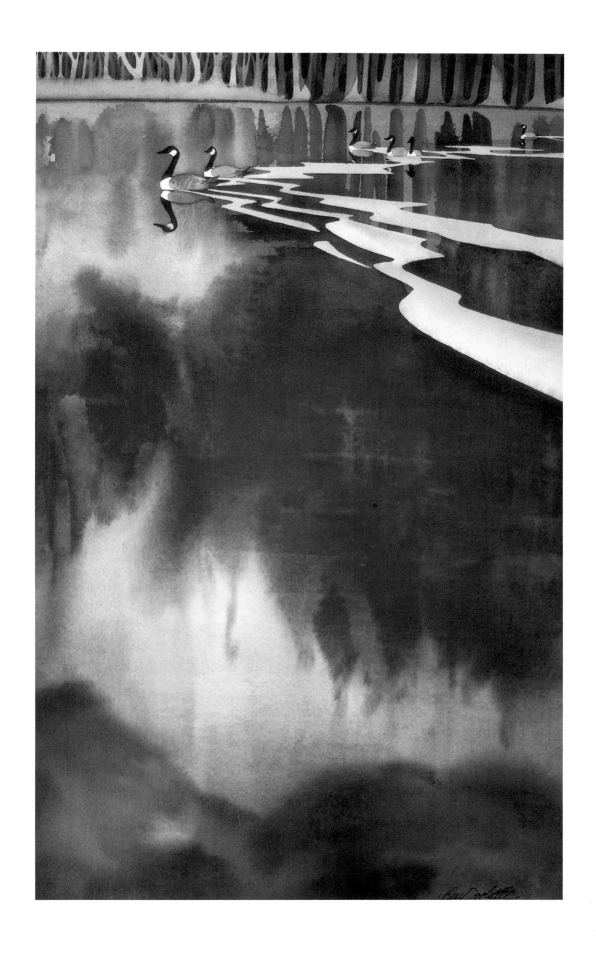

OUT IN THE OPEN • 1973

"A lot of my early work was in keeping with the impressionistic style characteristic of watercolor. But I was also very conscious of patterns. So this painting came out quite tight, with the lovely clean silhouetting that a winter landscape tends to create."

— Bev Doolittle

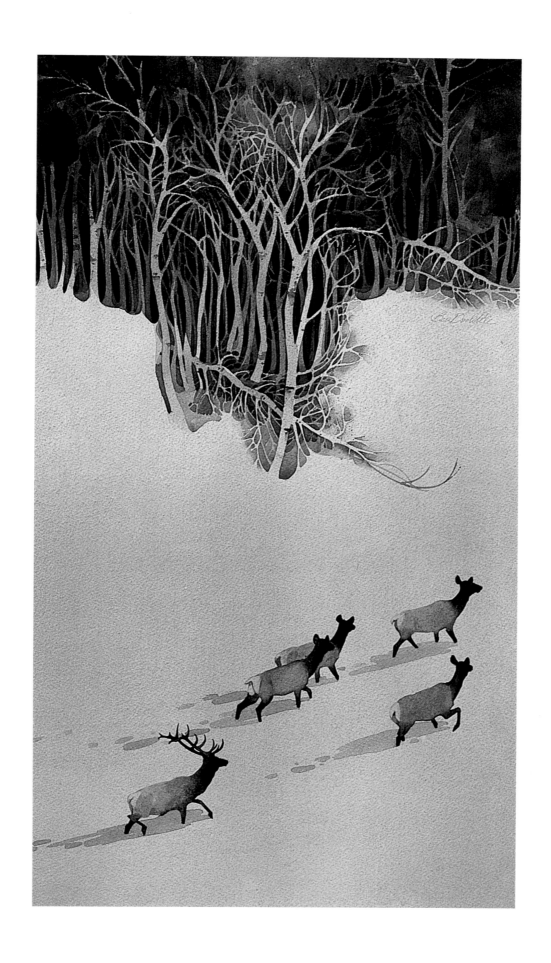

WINTER CAMP • 1975

*"Snow must surely be one of
nature's kindest gifts to artists. It
defines so clearly that all the shapes
it lines out, along with their shad-
ows, are thrown into sharp relief.
Of course it can get deep enough to
bury shapes as well, but that too
has its own interests that help to
clarify and balance."*

— *Bev Doolittle*

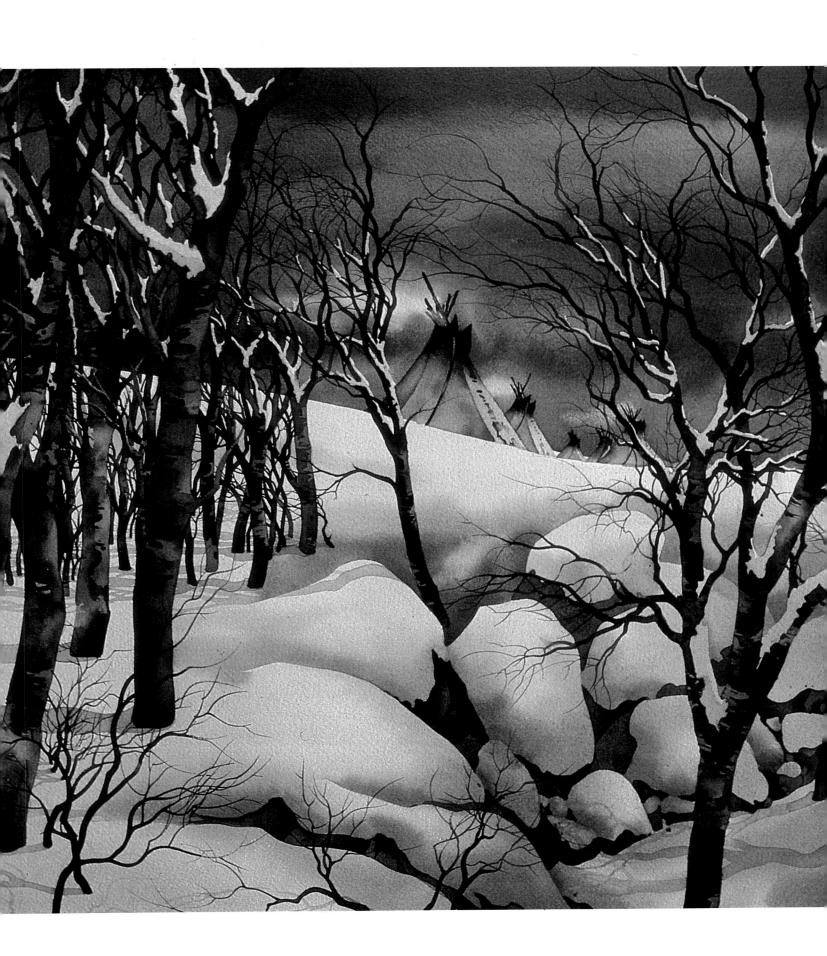

BUGGED BEAR • 1980

"One day I was following a hillside trail in Canada's Jasper National Park when I spotted a great blue heron fishing a shallow mountain pool. I crept quietly through the trees and brush to reach a good vantage point, and snapped a couple of photos. I then stepped out on to the muddy riverbank — and looked down directly at the big, unmistakably fresh tracks of a grizzly bear. At the time those footprints in the mud were the closest I'd ever come to a grizzly. Since then I've seen and even photographed them — at a distance — and I'd just as soon picture them happily sleeping off a big meal, nestled in a hillside of wild flowers!" *— Bev Doolittle*

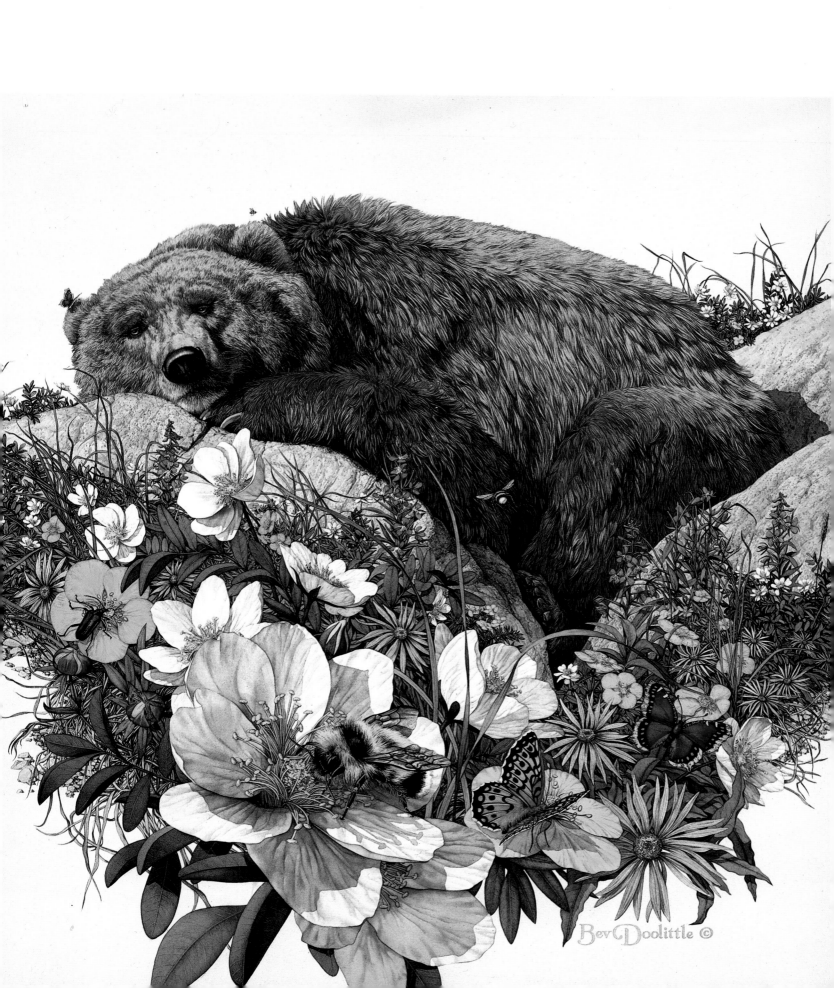

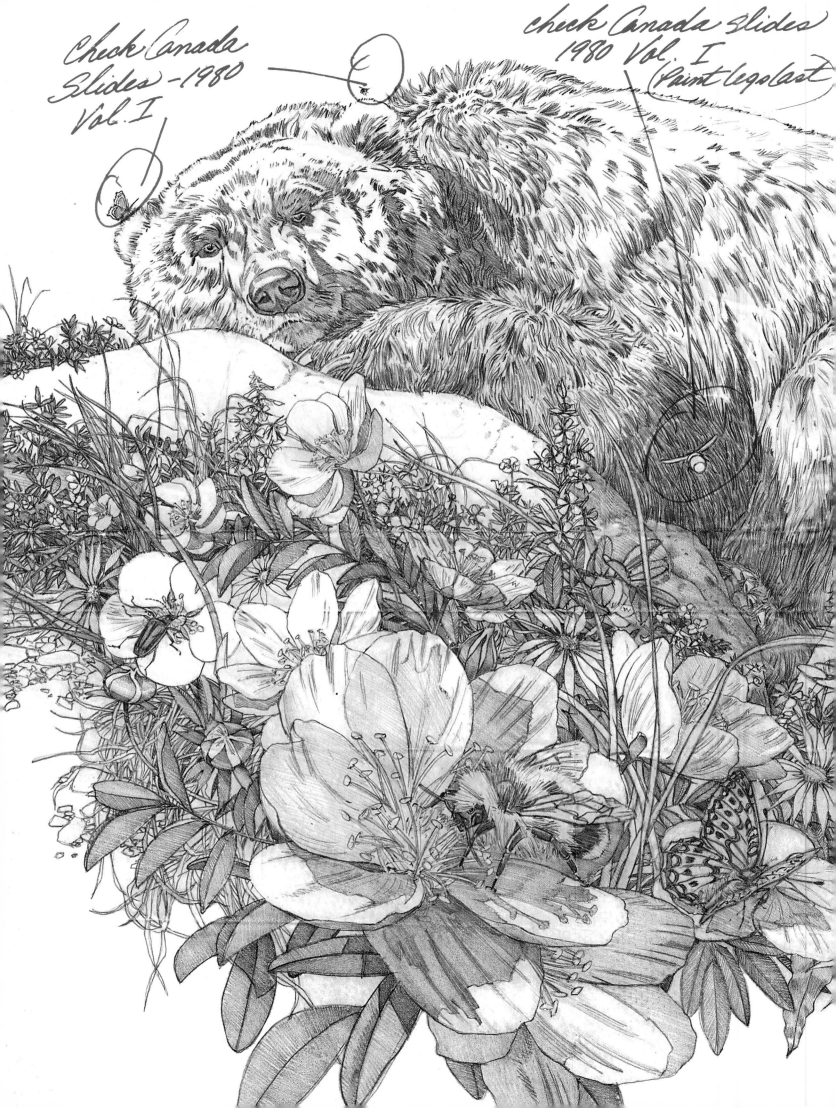

BUGGED BEAR *(Sketch)*

"The grizzly has pretty good defenses against the many insects of the far North — he has to have, to raid those wild beehives for honey — but still, there must be times when he longs for a little peace. Which is part of how Bugged Bear came into being."
— *Bev Doolittle*

BUGGED BEAR *(Detail)*

"I have literally hundreds of close-up shots of the tiny flowers, wild grasses, groundcovers, lichens and mosses that grow in the wilderness. These small things create a feeling of neighborliness, something one's own size, in settings that might otherwise be overwhelming." — *Bev Doolittle*

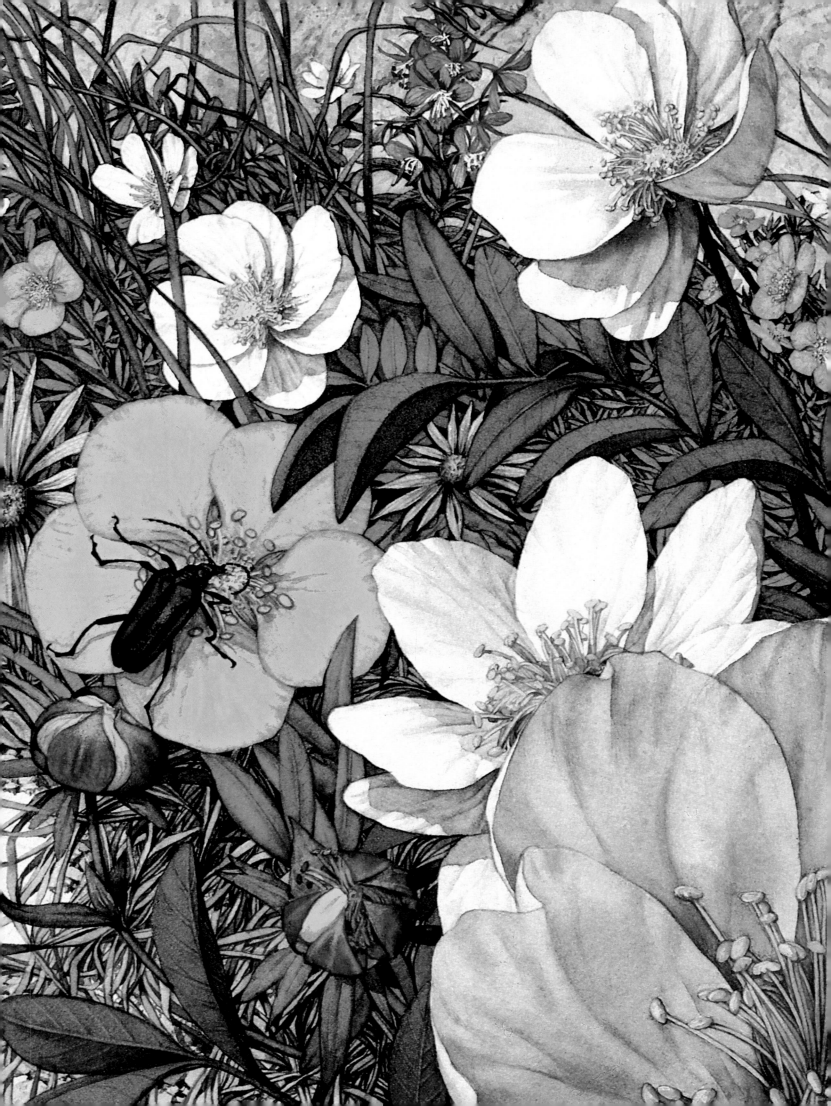

WHOO!? • 1980

"It was ten o'clock at night and still light. Jay and I were sitting quietly around a campfire on the edge of a small lake in a remote wilderness area of northern Canada. It was July, and the northern latitude gave us daylight until 11:00 p.m. We were the only two people camped on the lake; in fact, there was no one else in the entire valley.

Imagine our disbelief at hearing what sounded like large rocks being thrown into the lake. Closer scrutiny revealed the large rocks to be a beaver slapping his tail on the surface of the lake, loudly demonstrating his alarm and displeasure at having us camped so close to his home. The following day, we located his stick-and-mud lodge along the shore line. On subsequent evenings, we would crouch behind the lodge and take photographs as the beaver family emerged to gather leaves and twigs from the quaking aspen along the shore. This was my first encounter with beavers. They are interesting, comical animals, and I enjoyed putting one in the context of surprising a rather solemn neighbor — which also allowed me to play with unusual perspectives!"

— Bev Doolittle

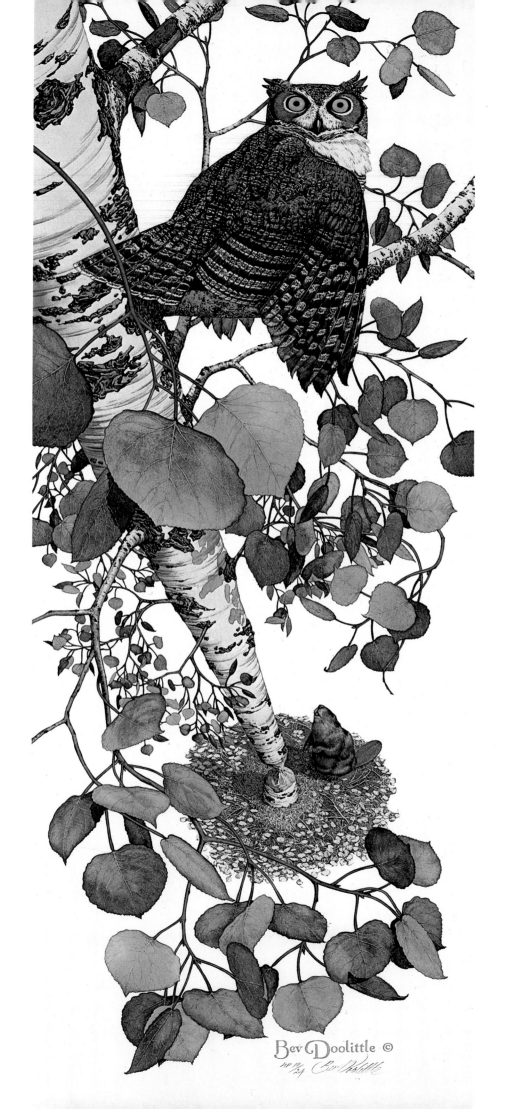

Bev Doolittle ©

WHOO!? *(Detail)*

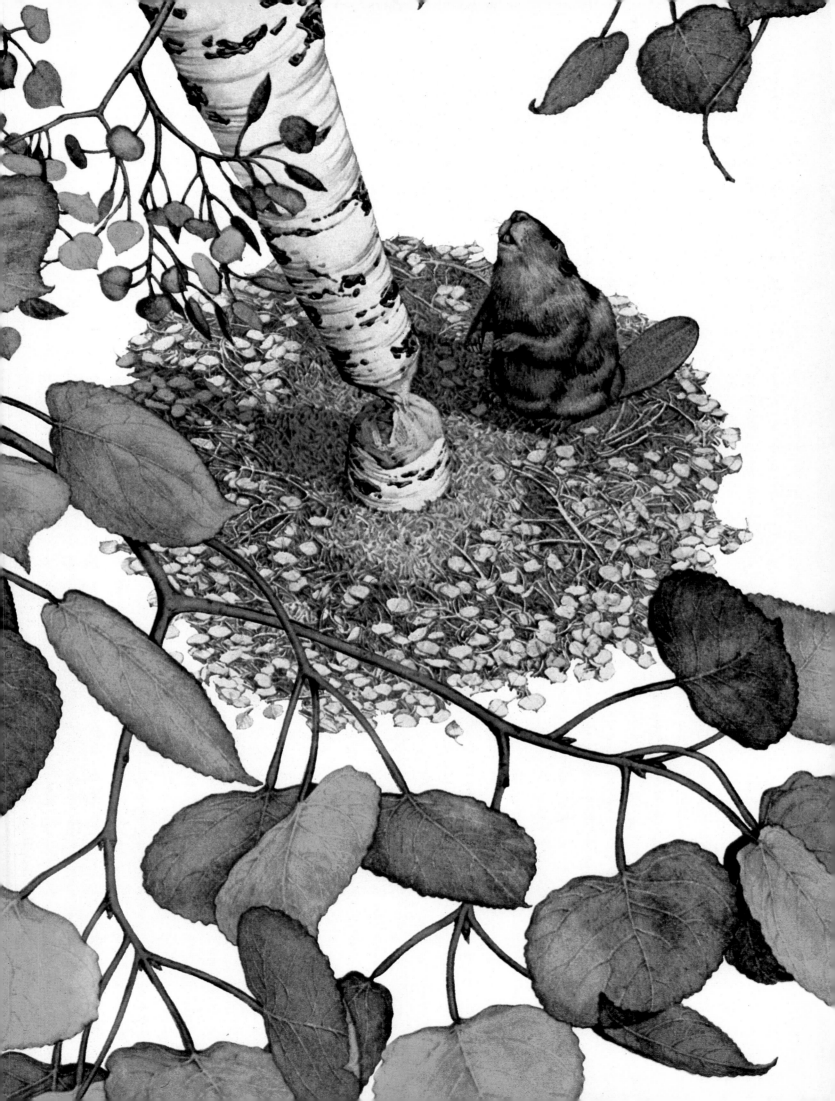

UNKNOWN PRESENCE • 1981

"When you're sitting around a dying campfire out in the wilderness late at night, somehow the silence gets intensified. In the North, 'late' is a relative term, but it's full dark, anyway. The mountain man has heard something out

there in the blackness. His horse has heard it, too. The man is experienced enough to know most night sounds: maybe he knows what it is and that's why he's reaching for his rifle. Or maybe he doesn't...."
— Bev Doolittle

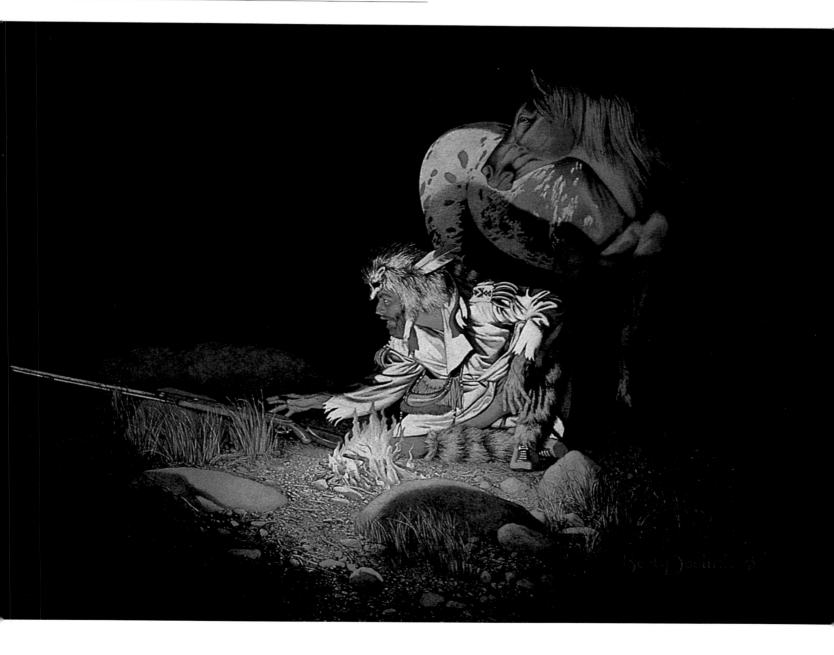

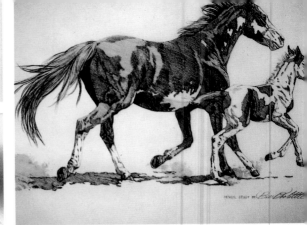

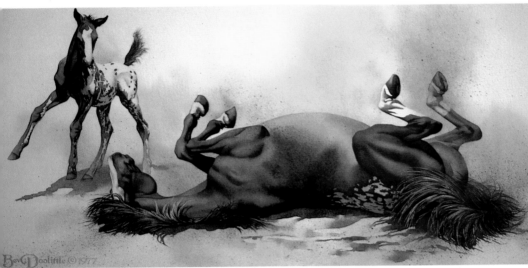

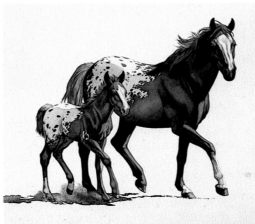

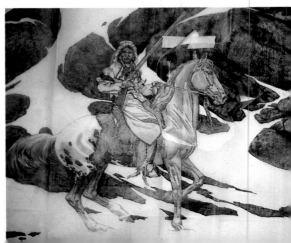

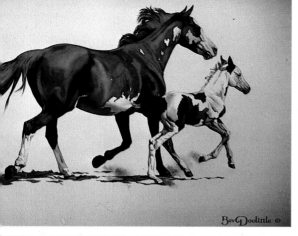

> *"I seem to have been drawing and painting horses all my life. They were among the earliest subjects I wanted to do. Their beauty, grace and strength still fascinate me, the variety of their expression and character seem endless. I must have hundreds of sketches, drawings and paintings of these beautiful creatures."*
> — *Bev Doolittle*

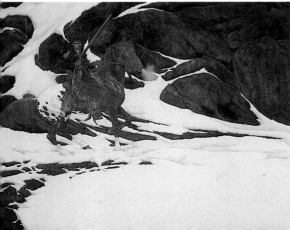

7 DECISIONS

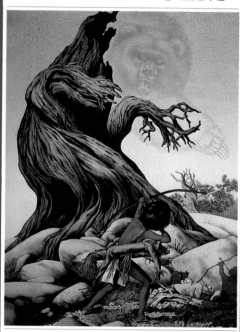

"...and with a child's
wild imagination I'd see
fierce animals everywhere."
—Bev Doolittle

When *Pintos* was exhibited at the American Watercolor Society's show in New York City it attracted the attention of two of the country's foremost publishers of fine art prints. One company sent a contract express mail to Joshua Tree.

The Doolittles were wary. From other artists they had heard tales of pressures brought to bear, subtle influences that worked themselves out in alterations of subject matter, style and technique. Bev and Jay knew that no amount of money could compensate for anything like that. They had not left the advertising world to pander to public taste. Their commitment was to fine art. It was a commitment for which they had already made sacrifices and were prepared to make more. Each painting must be the best they could create whether or not it was likely to be popular or suited to a particular use.

At the same time, it was becoming clear that Bev's evolving style was ideal for the print medium. Painting highly complex scenarios in exquisite detail was exactly what she did best and most wanted to do. Recognizing this and "looking for a way to sell a favorite painting and keep it, too," the Doolittles had already given quite a bit of thought to art print publication. They had even made a stab at doing it themselves.

The impetus was a painting called *The Grizzly Tree* that featured an Indian child stalking a gnarled tree which, in the youngster's imagination, had become a grizzly bear. Bev says, "I got the idea on a hike Jay and I took in the High Sierras, a backpack trip. Everything I saw suggested a story. I saw a tree that looked like a bear and I pretended I was an eight–year–old Indian boy with my first bow and quiver of arrows. Of course, I'd want to shoot every-thing in sight and with a child's wild imagination I'd see fierce animals everywhere."

"Kids really related to this painting. I once saw a whole group of them sitting on the ground talking about it. I got a lot of good feedback from adults, too; more than anything I'd painted up to that time. People said it would be great in a child's room. So Jay and I decided to try a print and market it ourselves."

Pricing their prints at $25, the Doolittles planned an edition of five thousand. Without advertising or distribution, they soon learned that figure was over ambitious, so although Bev had begun signing each print in terms of an edition of five thousand, only one thousand were actually produced.

"For a long time we had a lot of them lying around in our garage," Bev says. Later, after publishing *Pintos*, The Greenwich Workshop bought Bev's garage stash of *Grizzly Tree* prints—about two hundred—and quickly sold them all.

Before signing with The Greenwich Workshop, Bev and Jay got acquainted with its presi-dent, David Usher, who flew to Joshua Tree for a weekend visit. Jay says, "We liked Dave. He was open and candid. He answered all our questions in a straightforward way."

The visit ended with Usher inviting the Doolittles to an upcoming Greenwich Workshop seminar for dealers. Several of Bev's paintings, including *Pintos*, were put on display. The

dealers responded positively. Usher was cautiously optimistic and more than a little coura-geous. His decision to publish Bev's works was based on one available painting. It remained to be seen whether she could produce more.

B ev started as an unknown among a group of highly respected and well known artists. Luckily her style had crystallized and she found herself stimulated but not daunted by working in a context that included names like Frank McCarthy, Peter Parnall and James Bama. She told herself, "Everyone here can paint very very well. But even when our subject matter is similar, our paintings will be very different because we see things in different ways."

Bev's visions or ideas became her "signature." For the first time she became fully aware of the fact that her different way of seeing was the essence of what she had to offer.

According to stereotype, artists are temperamental, hard to get along with, easily distracted and prone to panic under pressure. The description simply does not apply to Bev Doolittle. She is cautious about making business decisions and seems to have chosen well. Her associ-ation with the Carson Gallery was a happy one, ending only when Carson suspended oper-ations for a few years. Now The Greenwich Workshop Gallery in Carmel, California, handles her originals. Both as an unknown artist, and later, after she achieved some mea-sure of fame, she has lived her life in much the same way, painting joyously and industri-ously and returning again and again to the wilderness for inspiration. The High Sierras are a favorite destination and inspired many paintings.

Although Jay and Bev often backpacked, they also went in on horseback with mules to carry their gear. Bev was fascinated with the mules, the saddles and the pack saddles, the details of buckles and knots. Often, she says, paintings composed themselves before her eyes.

Others developed later in her studio where she utilized elements she had photographed or sketched, arranging and rearranging them and playing around with ideas. In the photo of the mules being packed, things were going smoothly. But Bev asked herself, what if? and painted a somewhat different result....

With Bev's work selling well both in original and print form, the Doolittles decided to buy two small houses in Joshua Tree on land adjoining a boulder–strewn rise where they hoped to build their dream house some day. For the time being, they would live in one small house and use the other for a studio.

Feeling more financially secure, they made another decision and realized another dream. Jayson Bevson Doolittle was born in Palm Springs Desert Hospital on October 22, 1981. His mother's diary entry for that day read: "Jay and I have had 13 years of great times together and now we are ready to share our world with Jayson and acquaint him with life's wonders." Jay says, "Jayson really changed our lives and we wanted him to, but one thing we didn't want to change was our wilderness trekking." Before he was a year old, the Doolittle heir became a back pack rider.

Although Bev's work was more widely known, Jay had been painting steadily and had acquired a loyal following. A write–up in a Western art magazine was followed by gallery representation and brisk sales, especially in Alaska where a one-man show of Jay Doolittle's paintings was soon arranged.

Of the Alaska show, Jay says, "I felt a strong obligation to produce the body of work required. At this time Bev was working on *The Forest Has Eyes,* an incredibly demanding work, her most ambitious project to date. This was a difficult time for both of us. We managed to meet our obligations and take care of our son but it was really tough. We realized that it just wasn't going to be possible for both of us to be fully involved with individual careers and do a responsible job of raising our son. I decided to temporarily set aside my painting career and spend more time with Jayson and on the financial chores which were steadily increasing as a by–product of Bev's success in prints."

In spite of their heavy workload, Bev and Jay saw in the Anchorage art show a golden opportunity to take their first Alaskan wilderness trip. Two weeks prior to the show they had a bush pilot fly them up to an Arctic lake where they fished and camped and paddled down a stretch of the Alatna river. They enjoyed it so much that they have since taken three other float trips in Alaska. All have been on rivers above the Arctic Circle. Jay says, "I think we keep going back to Alaska because it is so remote. There is no feeling quite like seeing the bush pilot fly off and knowing that you are truly alone. The sensation of absolute silence and vast spaces. All the concerns and problems of our normal existence are quietly replaced by the more fundamental concerns of weather and shelter."

For Bev, every wilderness trip brought new artistic discoveries. In British Columbia, near the Racing river, the Doolittles stayed in a small hunter's cabin. Although it was midsummer, the painting which the scene inspired turned out to be a snowscene with the look of an abstract—a look which would integrate itself into more and more of Bev's paintings as time went on.

Wild strawberries grew near the cabin and Bev and Jay picked and ate some for breakfast every day—but not without having to compete with a small furry fellow hiding in the leaves. Bev did a painting of the problem, a small painting, only 5″ x 5″, but significant. She says, "I was getting onto the tricks that nature plays." She would soon master the art herself.

Sometimes a photo taken on a wilderness trip will spark an idea for a painting Bev will do many years later. Looking through her slides one day she came upon a photo of a snowbank near Red And White Mountain in the High Sierra. The snowbank, interesting but unspectacular against a field of scree, became *Season of the Eagle.* To achieve the drama she was after, Doolittle consulted other photos and transported the snowbank to a picturesque spot in the Rockies. It is late spring. The melting snow is a message from the Great Spirit: the high passes are open. A band of Crow Indians, traveling lean, begins the annual pilgrimage through the mountains to good hunting grounds beyond. The courage and free spirit of the eagle go with them.

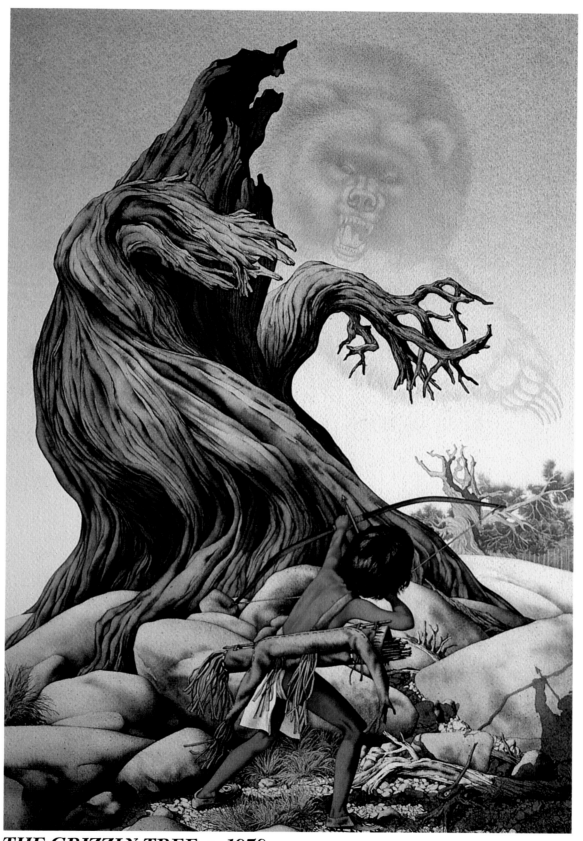

THE GRIZZLY TREE • *1978*

SEASON OF THE EAGLE • 1988

"In the life of the Indian, every new day, every encounter with bird or beast, and everything he owned or wore related to his religious belief that all creatures were the creation of the same great power, and therefore were brothers.

Because of the special reverence that Indians have for the eagle, I was particularly happy to find that hopeful message in the snow."
— *Bev Doolittle*

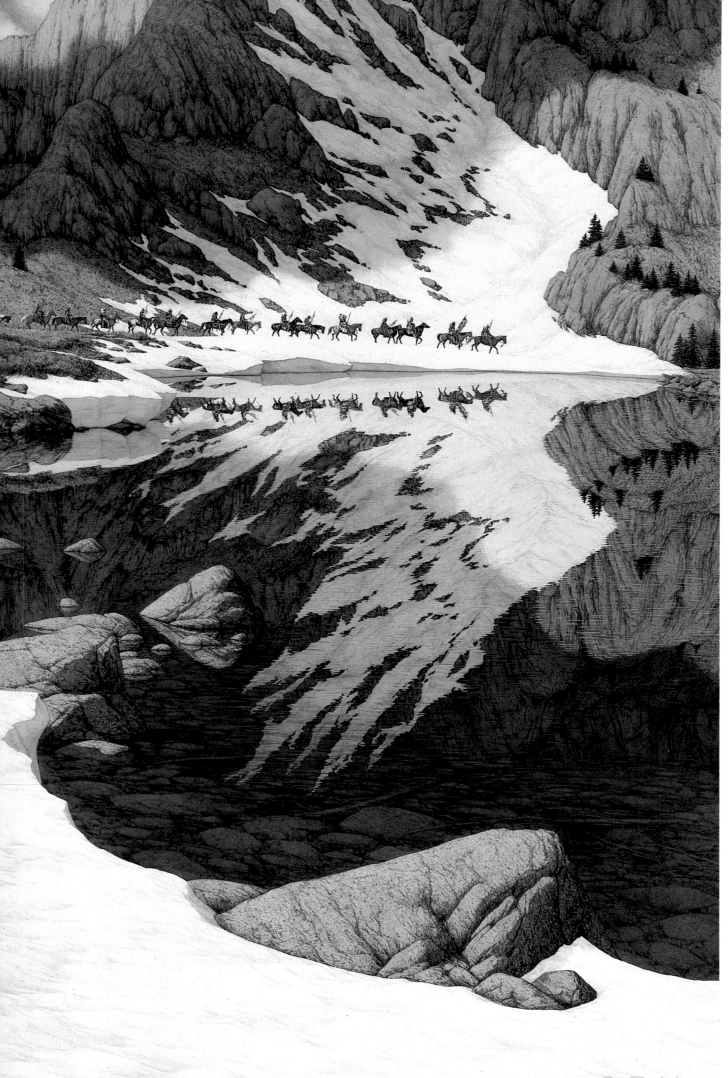

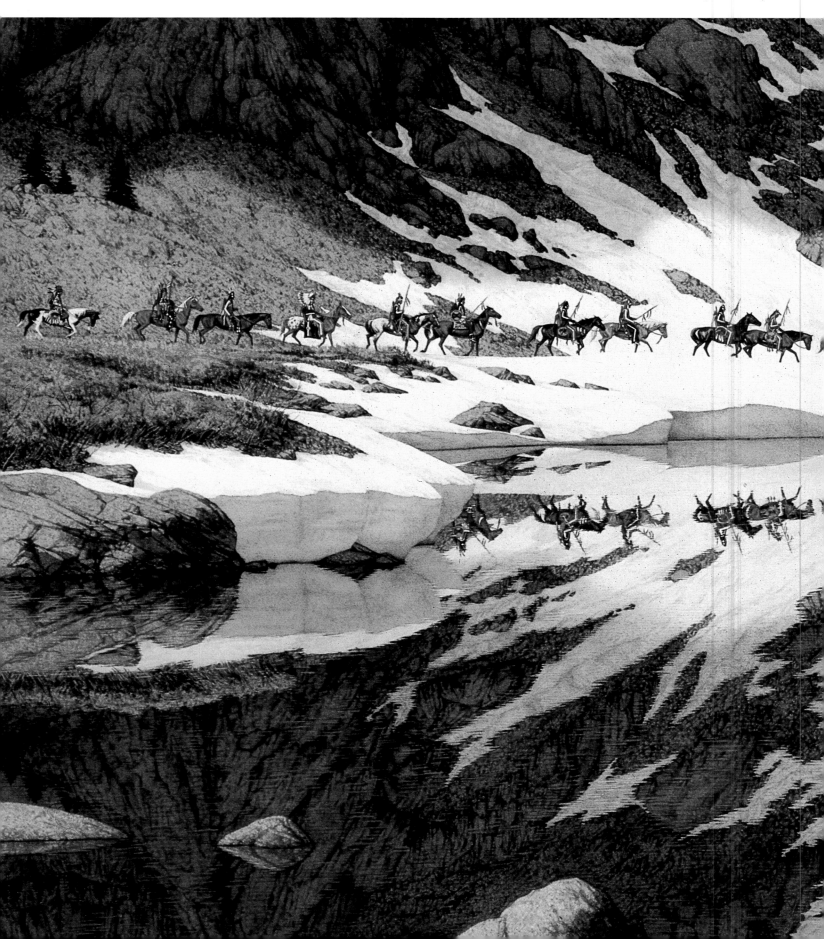

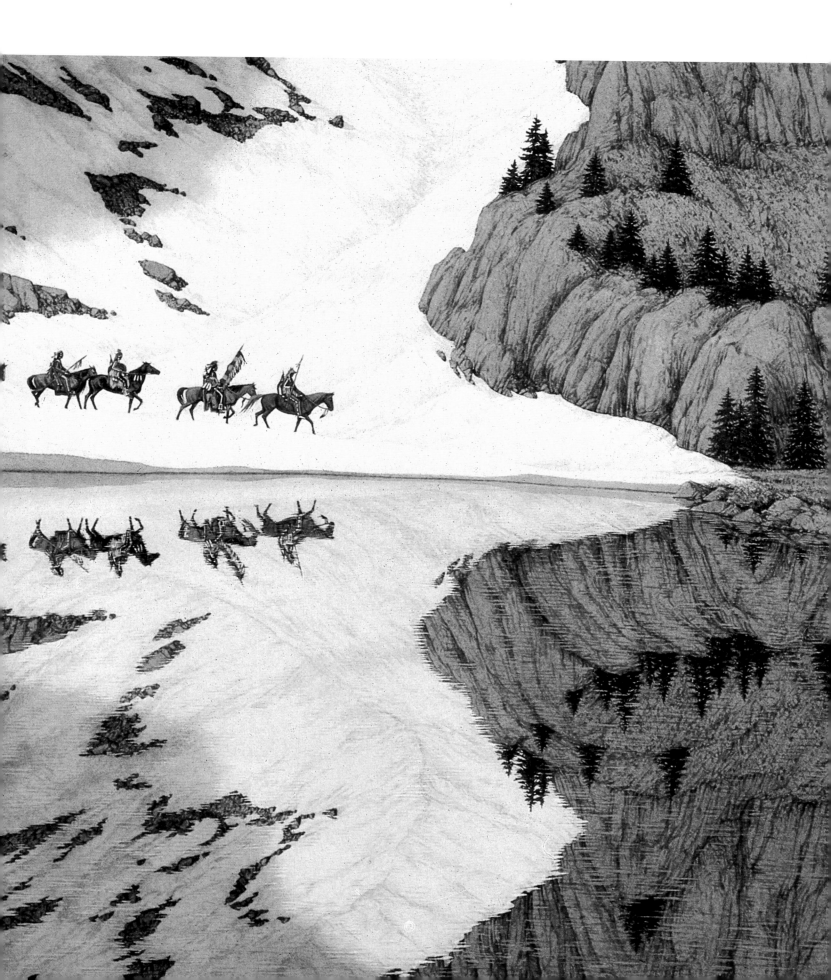

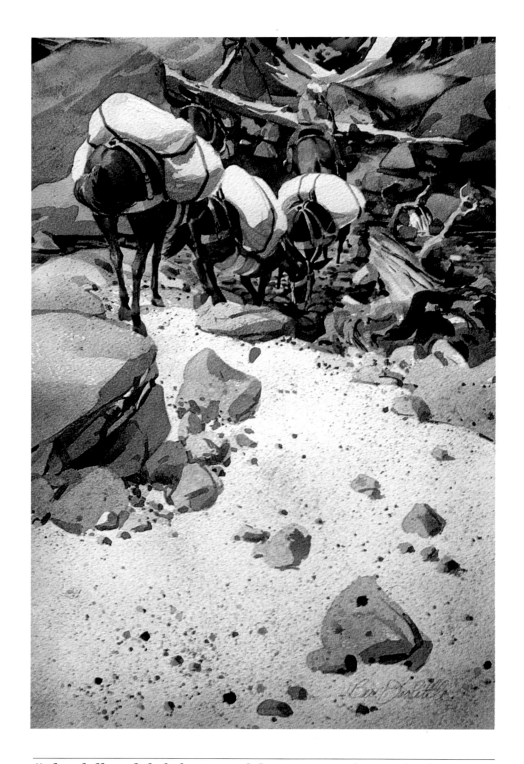

"The skill and deft footing of those great, clumsy-looking mules, even when loaded with unwieldy packs, fascinated me. I wanted to see what different lighting would do in this study and tried it several ways, eventually finding the rocks and dead tree limbs in the stream particularly helpful in the final design."

— Bev Doolittle

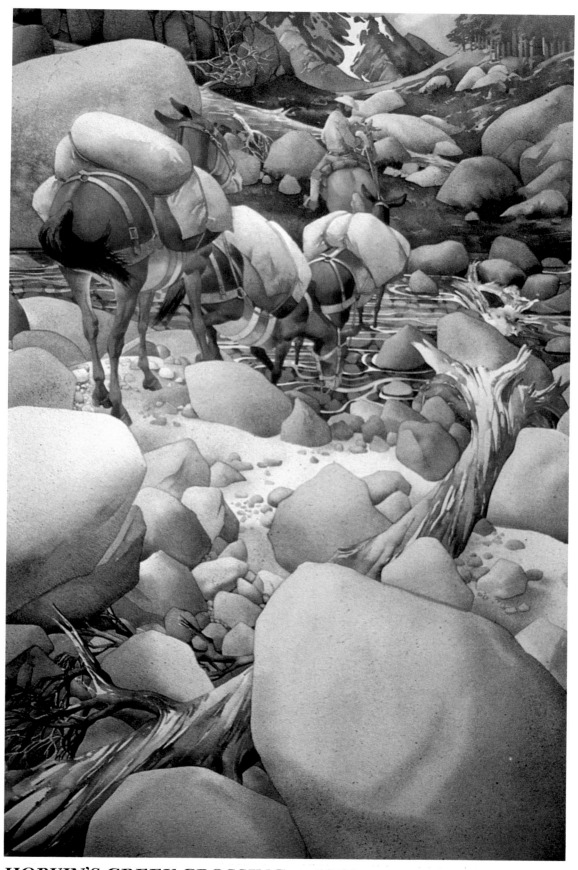

HOPKIN'S CREEK CROSSING • 1974

CHILI NIGHT • 1977

This is from the same period as AUTUMN SOLITUDE. There was a tiny cabin we stayed at way up in British Columbia — at least it looked tiny in relation to the mountains that surrounded us. When we got back to the studio I did a painting of what it might be like up there in early winter — not too much snow yet or the place would be buried. Inhabited cabins in snow almost always radiate warmth. And we had been so comfortable there in summer that somehow the place came out 'feeling' bigger than it really was."
— Bev Doolittle

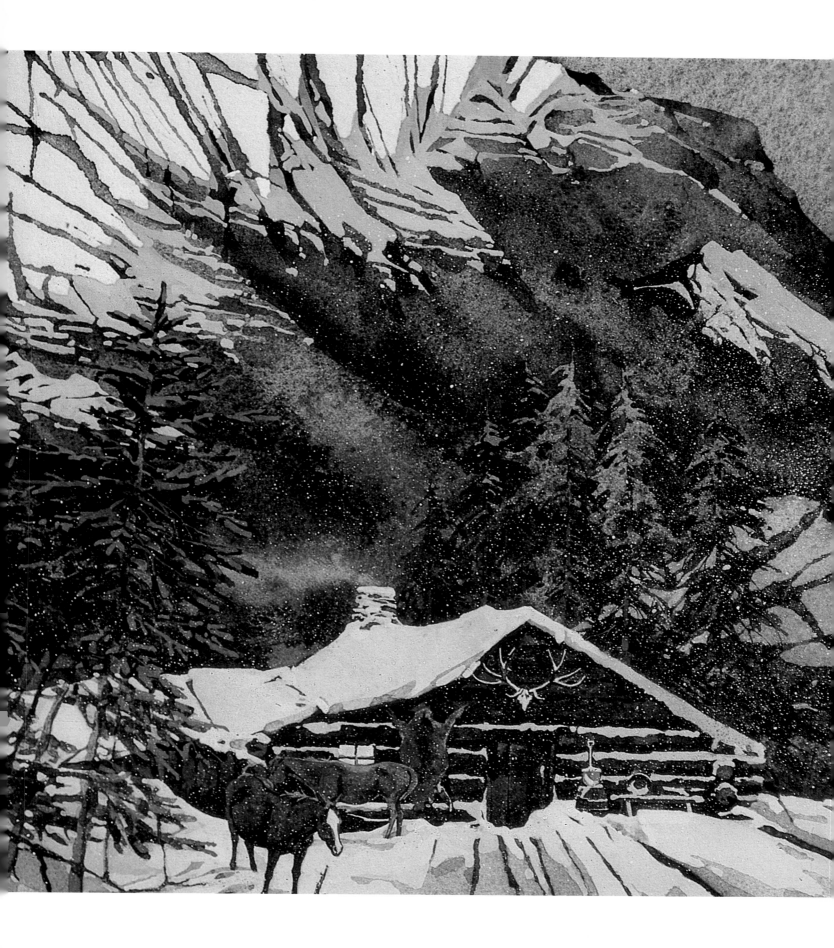

8
CAMOUFLAGE

*"I think that to find
meanings you have to look
at things from
different directions."*
—Bev Doolittle

Although people try to pigeonhole Bev's paintings, saying that they tend to fall into three categories—whimsical realism, camouflage art, and spirit paintings—most of her mature work includes much more than any one of these elements. Usually quite a bit is going on—on quite a few levels. There are stories and jests and poignant meanings, and tricks of color and shape that play on the eye.

Bev's genius is to show us different ways of seeing. Her own view of the world begins with the sheer joy of being alive. "Earth is beautiful and exciting and I feel blessed that I have been allowed to explore so much of it."

Living in the desert, backpacking into the Sierra, biking in Canada and paddling Alaskan rivers, Bev Doolittle's interest in landscape expanded to include the birds and animals that inhabited wilderness areas. She was especially fascinated by the way animals related to their surroundings. Her observation, "The smallest, most defenseless little things escape harm by blending into their environment," found expression in sketches and paintings.

And once she had trained her artist's eye to look for it, she saw examples of natural camouflage everywhere. Above the Arctic Circle and in her own backyard. A snowshoe hare, white on white against the snow. A cottontail photographed outside the window of her studio barely visible in the dusty light of late day.

Doolittle says, "It delights me to find things that fit so neatly into their habitat." But she chose to do more than merely document the phenomenon. The animals she would paint must be anatomically accurate and true to their essential nature. "I had to know them intimately in order to paint them." So she spent hours studying animals and, true to her own nature, sharing her discoveries with son, Jayson. There was the porcupine that went bump in the night on the porch of a cabin in British Columbia. Bears left calling cards in the wilderness. And in the Doolittle's own desert backyard, there were hawks and hares, coyotes and tortoises.

Of course, when it came to painting these animals, Doolittle saw them through the filter of her imagination. In one vignette, a butterfly hitches a ride on an ancient steed. In another, a tortoise, like an armored tank, lumbers past a coyote drowsing because, as the painting's title points out, it's *101° in the Shade.*

Hours spent observing animals yielded more than information. It taught the artist to be still and "listen with her eyes." She came to feel that "the animals that live in the wild have a certain wisdom and insight. They seem to understand and sometimes smile at urban civilizations."

With the gift of stillness came a sense of identification. When a red-tailed hawk cast his shadow on the desert, Bev was able to feel as well as see the rabbit's controlled terror and

instinctive freeze as it girded for a life–or–death dash. And so she was able to paint the scene in such a way that we, too, can feel as well as see.

Camouflage, Doolittle realized, is more than a matter of color. Movement—more often the lack of it—is also an aspect. "Ruffed grouse," she points out, "are particularly good at holding so still you absolutely cannot see them. But to defend their young, they will flutter and carry on, leading the eye of the intruder away from the helpless chick—using movement as a form of camouflage by misdirection." The observation inevitably found its way into an early painting. "I had fun misdirecting the viewer's eye, having the bird fly straight at you so that you can't help but look at it first. Then you realize there's an Indian there who may have startled the bird."

Through the years, Doolittle has taken this idea and developed it so that today she is as much in command as a conductor with a baton. "I like to take the viewer's attention and move it around through a painting so that you see one thing first, then a second, then a third, each time seeing something new."

Easier said than done. Bev struggled for weeks, making endless tissue overlays, adding and subtracting elements before coming up with her highly successful *Pintos*. In this painting, the horses see the viewer before the viewer sees the horses. Ears prick, nostrils flare and as one, the group turns its eyes upon—an Indian, a horse thief, a tourist with a camera. Getting the idea to work was satisfying and liberating. "Suddenly my mind was crowded with experiments I wanted to make, patterns I wanted to play with, stories I wanted to tell."

One of the stories Bev Doolittle wanted to tell was her feeling that the wilderness bears the imprint of the Indians who lived so close to it for so many years. Often, she says, she has felt these spirit presences hovering just beyond the borders of perception. *The Forest Has Eyes* is her attempt to share this feeling with the viewer.

At first glance, *The Forest Has Eyes* might appear to be a trick painting. But Doolittle's works must always be looked at again and again, for they convey more than one message. Here we read the story of a mountain man, not easily frightened but wise in the ways of Indians. Passing through Indian territory, he is wary. He is also alone, has been alone perhaps too long, and that is when the imagination takes over, creating images and persuading us that they are real. But even on the simplest visual level, our eyes play tricks. Look at the photograph which inspired the painting—Bev crossing a stream. Do the rocks form faces? Does the forest have eyes?

The Forest Has Eyes is an elaborate, complex painting entailing an enormous amount of work. Without a doubt, Bev Doolittle would have undertaken it no matter what. However, it was pleasant to be able to justify the expenditure of time and energy with the thought that as a fine art print thousands of viewers would be able to enjoy it.

ESCAPE BY A HARE • 1978

"One day, while I was jogging on one of the many trails around our place in Joshua Tree, a hare shot out of the brush right across my path, immediately followed by a coyote. Both animals ignored me completely.

Later I put the episode together with another experience one has in the desert, and did a painting of the shadow of a different predator in pursuit of its prey — but I made sure, in the title, that the hare got away."
— Bev Doolittle

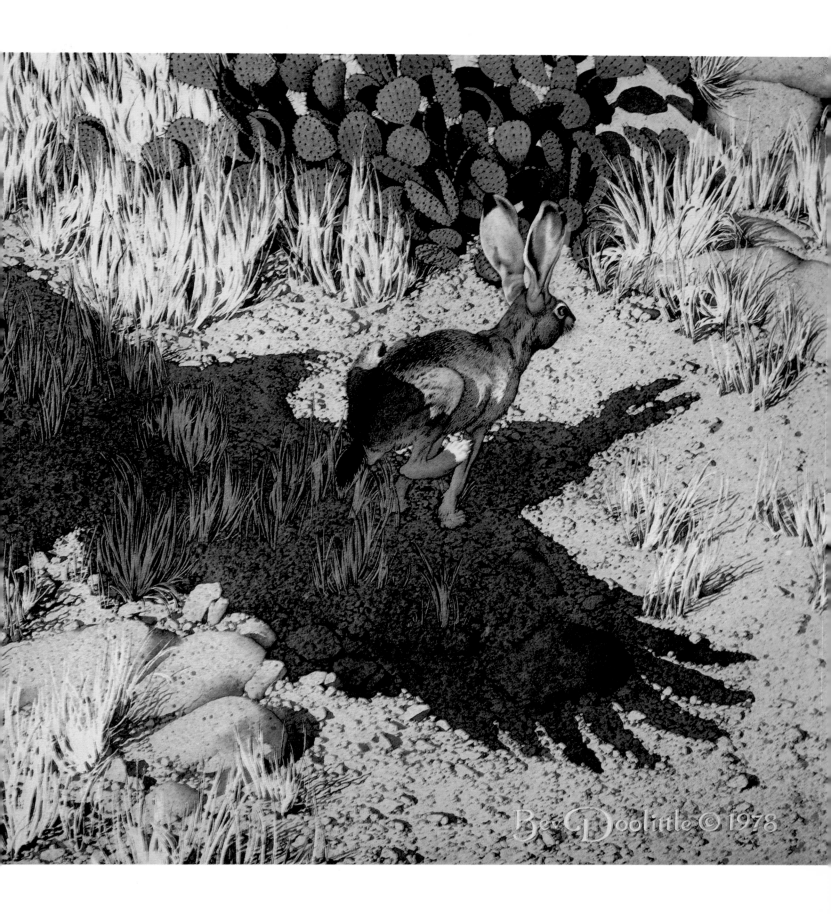

Yet Bev has been consistently unwilling to duplicate her work. When a problem was solved, she was no longer interested in it except as history. She posed new questions, sought new answers even though that meant months of thinking and planning before she could do what she loved best—put brush to paper. In Jay she found not only enthusiastic support, but also honest criticism and imaginative contribution. The planning stage, which many artists find tough, frustrating and lonely, became a shared adventure.

Like her works, Bev Doolittle has hidden qualities—the impish wit that surprised everyone at the advertising agency, the courage to tackle the most prodigious new projects, and an amused audacity that resulted in a tour–de–force painting called *Woodland Encounter*, which appears as a foldout (p. 32).

"When I painted *Woodland Encounter*," Bev says, "I wanted to see how many rules I could break. For example, we habitually see the foreground of a picture first, then the middle-ground, and finally the background. I wanted to reverse the process, to get the viewer to see the background first and the foreground last.

"To do so I decided to place a bright object, a target for the eye, in the very center. Of course, you're not supposed to center things, so as long as I was breaking that rule, I decided to take it a step further. With the fox in the middle, I divided the painting in half. I centered an Indian in the left half of the painting and put the other Indian in the exact center of the right half. The next step was to choose a landscape that was distracting enough to make it fun for the viewer. I chose a landscape in the Rockies, a place where the trees look two–dimensional, almost like wallpaper."

Doolittle's industriousness and capacity to take pains are evident in one of her most popular camouflage paintings—a puzzle painting with a hint in its title: *Two Indian Horses*. She harbored the idea a long time before painting it. The line of horses. The cavalryman walking away. The Indians. A dramatic incident about to happen. An ordinary day about to become a tale of Indian ingenuity. And for the artist, an enormous research problem, entailing a trip to the U.S. Cavalry Museum at Ft. Riley, Kansas. Here Doolittle learned that while she had planned to show four to five horses, a cavalry patrol would probably consist of at least twelve. The saber she had sketched was authentic but the soldier, knowing it would be too cumbersome for use in Indian engagements, would have left his back at the fort. So in the finished painting he carries a carbine. The Blackfeet Indians in the picture behave as they would naturally have done, leaving their horses at a distance so as to approach unobserved. Faces painted, wearing ermine tails, they glide among the aspen trunks, perfectly camouflaged. Two cavalry horses are about to become two Indian horses.

Doolittle explains, "I wanted the viewer to share the experience, to see the horses and the cavalryman first and only later discover the Indians and what they were up to. As a rule, most people view things from left to right...it's a habit from reading. So I oriented the painting to the right—placed the cavalryman there and had the horses looking to the right. I also placed really bright horses at intervals to pull the viewer's eye along.

"Some people take a long time to discover the story here. Others see it right away."

SNOWSHOE TRACKS • 1975

TWO INDIAN HORSES • 1985

"The sequence in which the viewer discovers the elements in a painting is planned. In this one a regiment of the Second Cavalry takes a short reconnaissance ride from Fort Ellis, Montana. The soldiers have stopped to rest the horses before moving on to complete the last of many such patrols before the onset of winter.

Most of the horses are watching their owners stride off to the right. Those two Blackfoot Indians on the left are about to be two horses richer."

— Bev Doolittle

Bev Doolittle ©

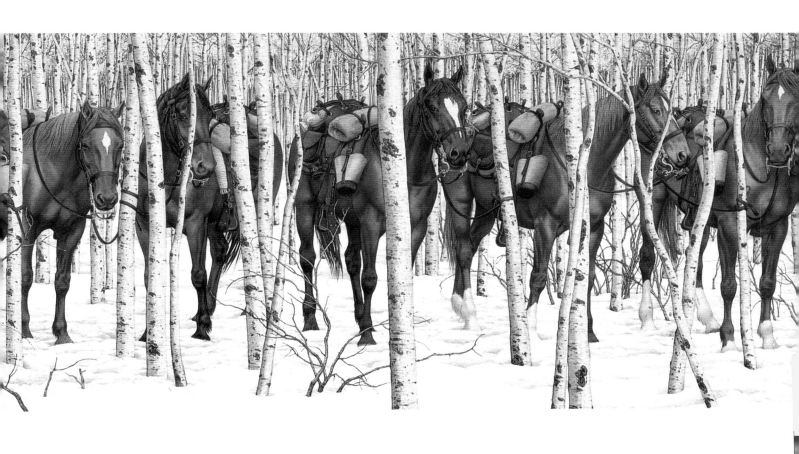

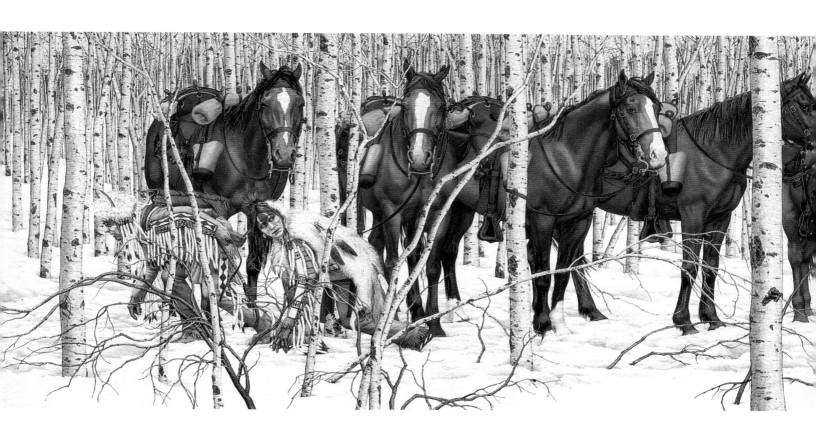

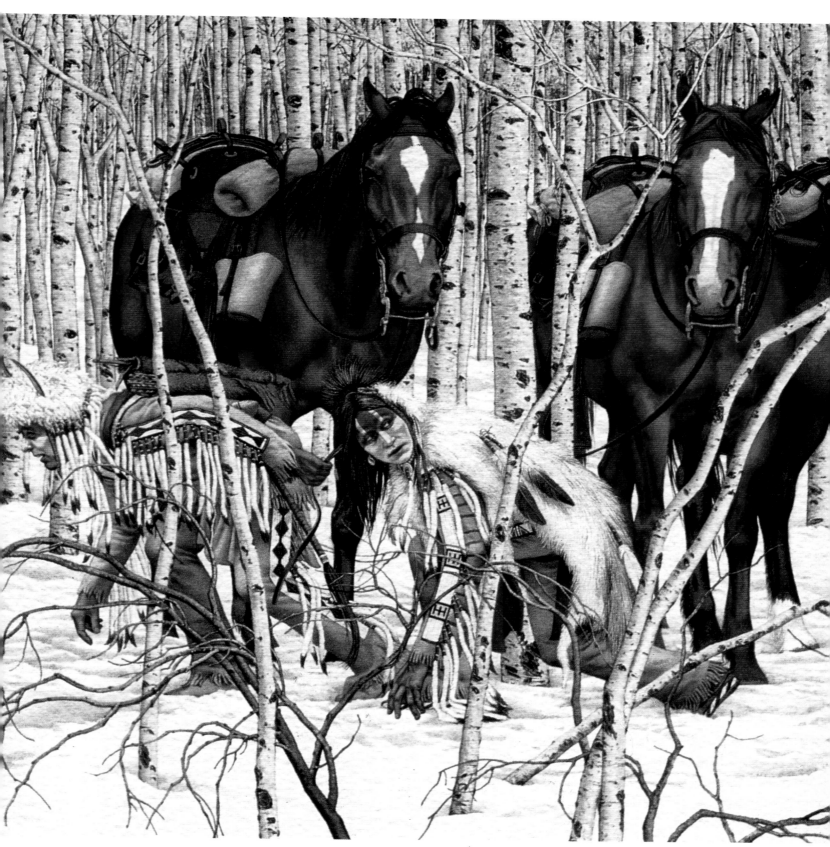

TWO INDIAN HORSES *(Detail)*

EAGLE'S FLIGHT • 1983

...through his mane and tail the high wind sings,
Fanning the hairs, who wave like feather'd wings.

"This line from Shakespeare was the inspiration for
Eagle's Flight. I wanted to portray the words in
both a literal and a symbolic way. I drew the horses
in a state of fluid motion to emphasize speed and
power. On a symbolic level, I arranged the horses
and Indian in such a way that all the darks in the
painting would create the image of an eagle in
flight. The use of eagle feathers as decoration on the
horses was also to emphasize the feeling of flight."
— Bev Doolittle

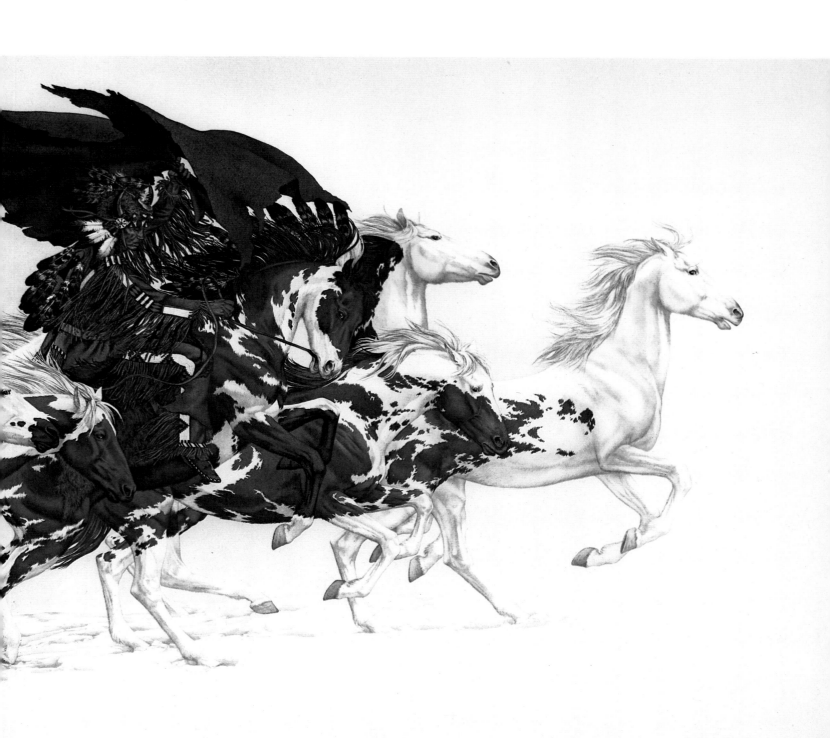

THE FOREST HAS EYES • 1984

"I want the viewer to share the emotions of the rider, and — as he does, because his life depends on it — 'read' the story in the leaves, branches, water and stone that surround him."
— *Bev Doolittle*

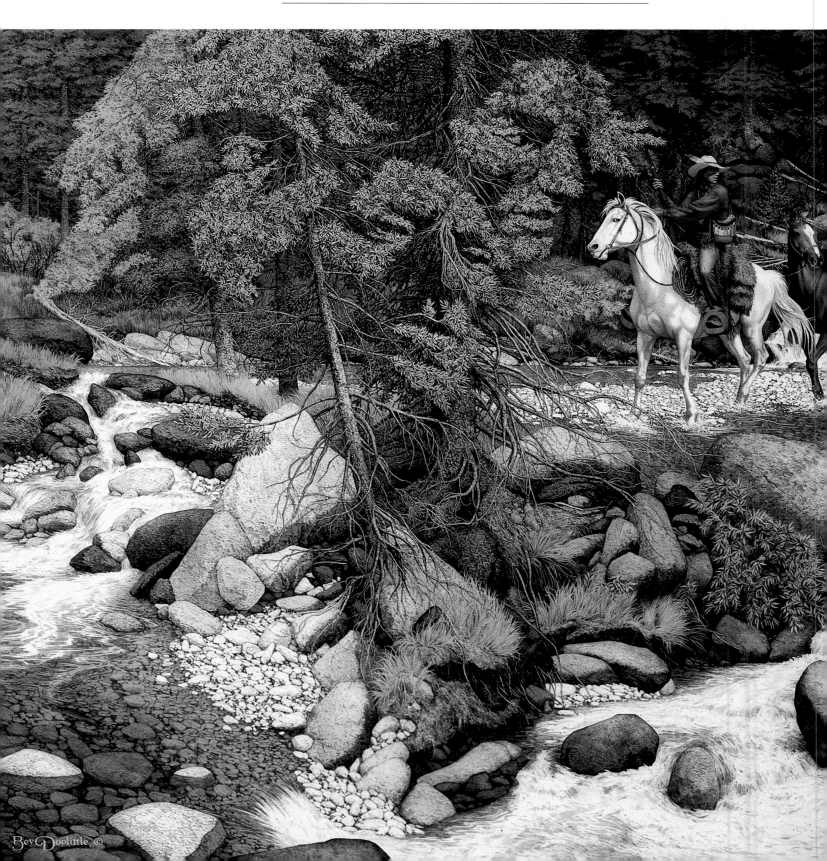

Bev Doolittle ©

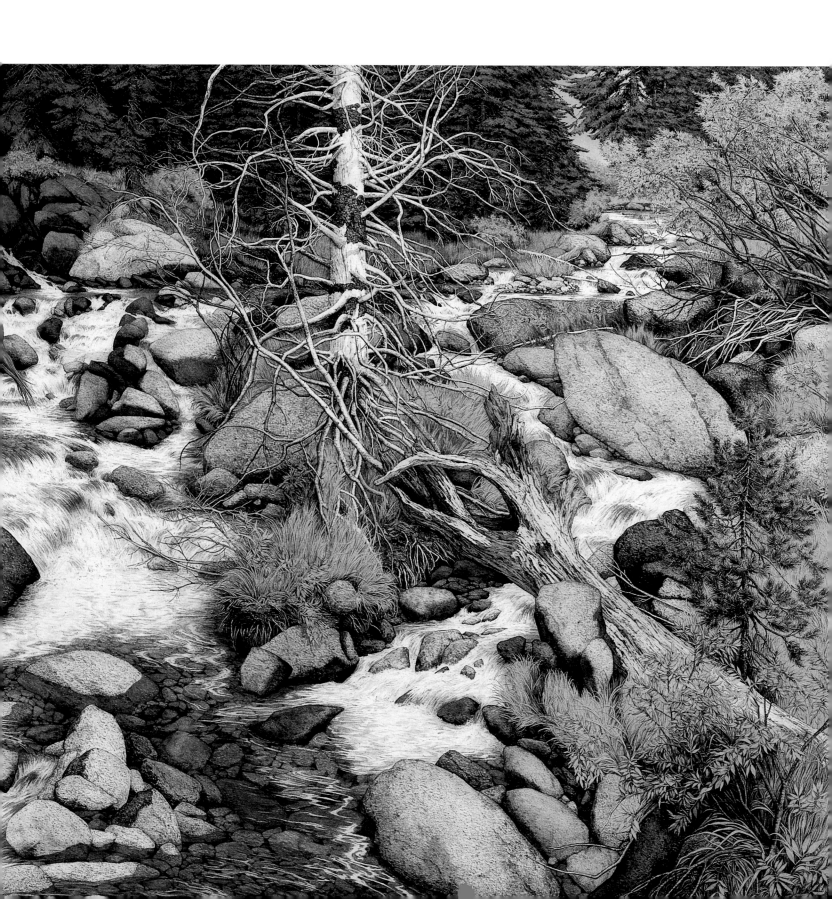

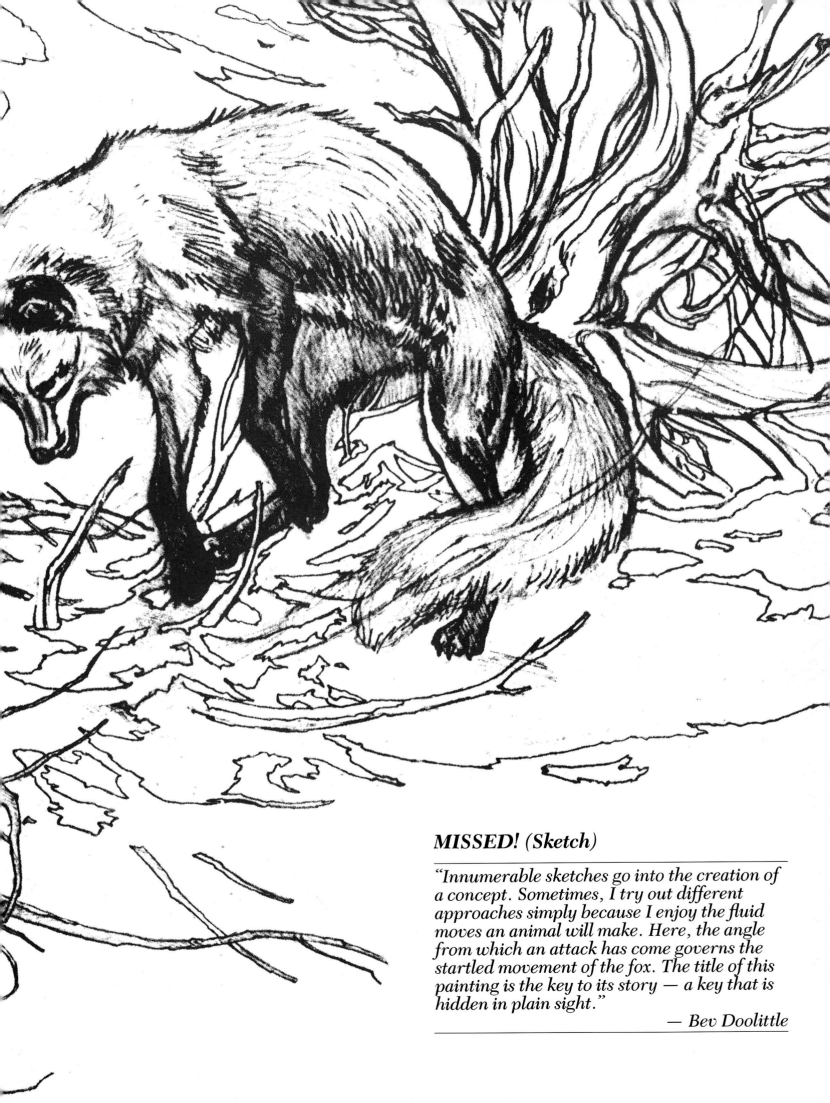

MISSED! (Sketch)

"Innumerable sketches go into the creation of a concept. Sometimes, I try out different approaches simply because I enjoy the fluid moves an animal will make. Here, the angle from which an attack has come governs the startled movement of the fox. The title of this painting is the key to its story — a key that is hidden in plain sight."

— Bev Doolittle

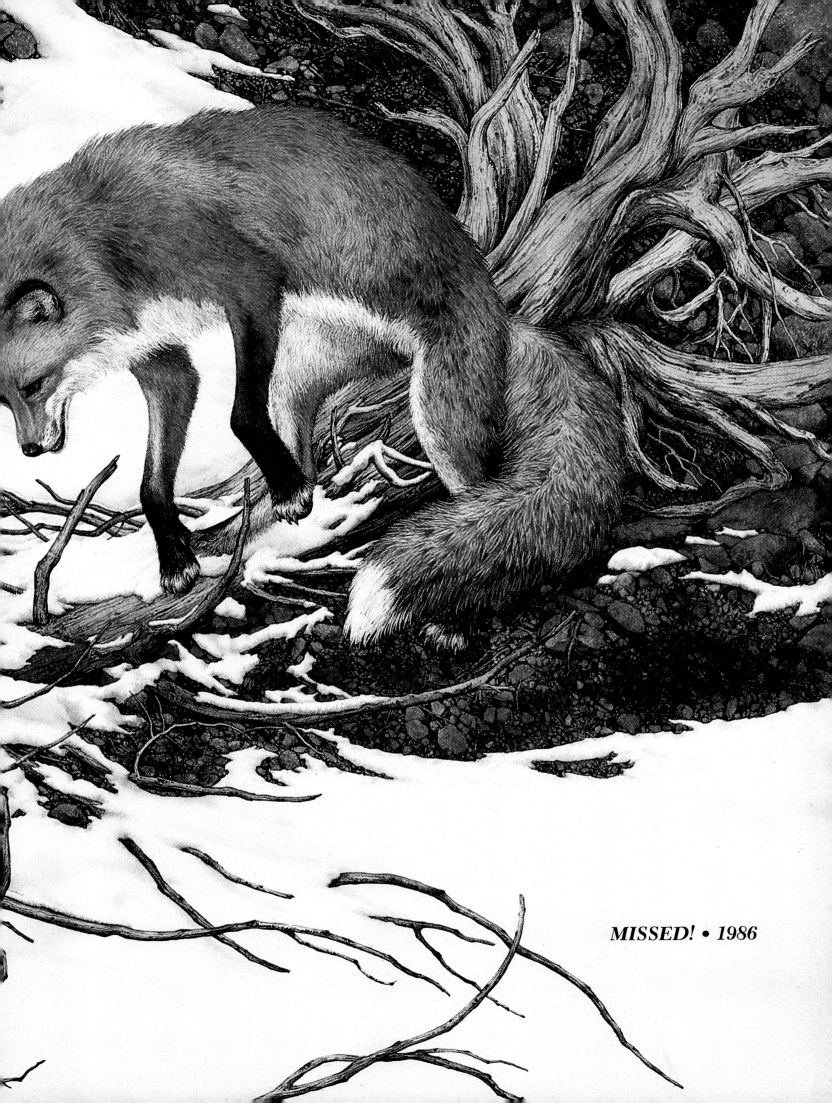

MISSED! • 1986

9
SPIRIT PAINTINGS

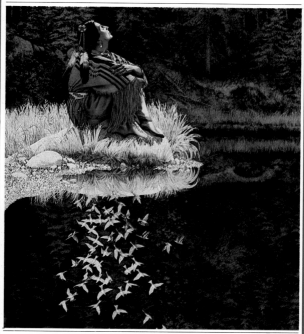

Blackfoot. Sioux. Ojibway. Crow.
The tribes are scattered like red leaves.
The thunder of the buffalo is heard no more.
The sacred trust is a splintered bow.
But the eagle remembers.
And the wolf and the bear.
You called us brother, we are brothers still.
You run with us. You always will.
—Elise Maclay

Bev Doolittle's fascination with the culture of the American Indian grew from the day she and Jay found that handful of obsidian arrowheads in a public campground near Yosemite National Park. To paint these people whose moccasin prints were somewhere deep beneath the tread marks of her hiking boots, she needed to know a great deal more. She turned to museums, to books, visited Indian reservations. She learned about the Mandan, the Sarsi, the Comanche, the Cree; what they wore; what their baskets and beadwork looked like. She learned about shields and lances, medicine bundles and tepees. She learned how Plains Indians hunted the buffalo, how they used the bones for knives, shovels, splints and game dice; how they filled pillows and saddle pads with buffalo hair and braided long strands of it into rope. She learned how they taught their children to ride, how they emulated the wolf and admired the eagle.

Most significantly, she discovered that these ancient people viewed life much as she does. Like them, she loves the wild beautiful earth and believes she shares it with her bird and animal brothers. She says, "For me, nature is a religion. Like the American Indian I sense in the wilderness the spiritual side of the unknown."

As the early Indians did, Bev Doolittle goes to remote and beautiful wilderness areas for spiritual refreshment. In the depths of the forest, beside a tranquil lake or amid the grandeur of the Rockies, it does not seem strange to her that a reverent Indian might receive a "vision," a sense of direction and protection.

Often this vision took the shape of an animal or bird—eagle, wolf, buffalo, bear—with attributes to emulate and power to inspire.

Calvin Goodman, writing in Western Art Digest, reminds us: "Ralph Waldo Emerson would have been quick to recognize the animism of the Plains Indians as not too far from the American Transcendentalist belief that we can find the Divine Essence in Nature."

Artists like Thomas Cole and Frederick Church were also keenly aware of the mystical significance of the unspoiled wilderness. However, Goodman says, "While these nineteenth century Hudson River artists were interested in showing us the grandeur of the wilderness itself, this twentieth century artist (Doolittle) is more concerned with the people who inhabited that wilderness, their views of themselves and of their surroundings."

What Bev Doolittle is trying to paint when she paints Indians is best said with her brush. But it is important to note that while she is fascinated with the customs and costume of various tribes, what she wants to portray is the way these remarkable people related to the earth—were, in effect, one with it and with all its creatures. As an artist, she seeks to make graphic their appreciation of natural beauty and their gratitude to the Great Spirit. If she has a mission, it is not political and it is not confrontational. It is simply to help us find something we may not know we have lost.

"Something hidden. Go and find it. Go and look
behind the Ranges. Something lost behind the Ranges.
Lost and waiting for you. Go!"
—*Rudyard Kipling*

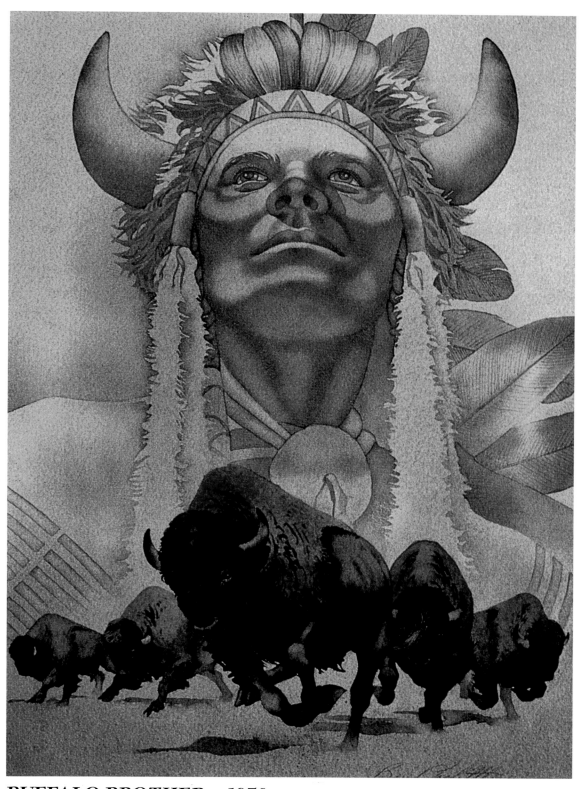

BUFFALO BROTHER • 1976

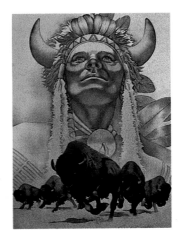

Buffalo Brother is an early painting in which Bev Doolittle is beginning to think about the way the Plains Indians related to the herds of buffalo that once rolled like dark waves over the prairie.

By the time she painted *Runs With Thunder* she was able to transport the viewer to the heart of the action, to gallop with the Sioux warrior and feel his heart pounding as he nears the powerful herd. Thunderheads are piling up in the sky and lightning flashes as Bev has so often seen it on the desert near her home.

Let My Spirit Soar began with a place: the sunlit shore of a lake in Banff National Park. As soon as she saw it, Bev Doolittle knew that she wanted to use it as the setting for a painting.

When she returned to take photos, she had a specific subject in mind. She thought she would paint an Indian woman standing near a deer, or possibly just the reflection of a deer. But as she sketched and made charcoal studies, a more insistent vision took over. She saw a daughter of the Blackfoot tribe, sitting in the sunlight, dreaming dreams that fly high and free as the birds.

From the Museum of the American Indian, Bev obtained a photograph of a beautiful Blackfoot Indian dress. Then, because "you can't guess the way the folds will fall," she bought some fabric and actually created such a dress, cutting and stitching it herself. She got a friend to pose wearing the garment. "She was Greek but she made a very good Indian when I changed her nose a little."

Researching birds, she chose to portray pine siskins because they are tiny and tend to fling themselves into the sky like a handful of stars.

Here, as in many of her paintings, Bev Doolittle suggests that the real and the unreal coexist and may even be one and the same. Indian legends tell of Changing Woman who was made from a piece of turquoise, who was found in a cradle made of rainbows wrapped in a purple raincloud held in by side lacings of lightning. Perhaps we are looking at her portrait.

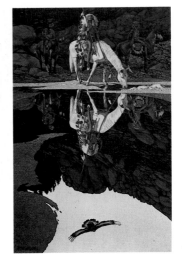

There is more here than meets the eye—or rather, the way it meets the eye is part of the Doolittle magic. Three Crow Indians look up. To see what they see, we must not follow their gaze but use our own eyes and consult the reflections in the water. The mystery is solved. A golden eagle soars high above the canyon walls, an embodiment of the Great Spirit. A good omen.

In an era of trick photography and computergraphics, we almost assume that Doolittle has achieved this effect by some mechanical means. But she works in transparent watercolor and to depict three Indians and their reflections she must paint six Indians, three of them exact duplicates of the originals, taking into account also the fact that not every mirror image is whole. We can prove it by holding the print upside down. Looking closely we notice that when the picture is inverted, the sand goes *over* the horse's mouth. More significant is the fact that when the painting is in its proper position it casts a stronger spell.

As Kipling said, surely the gods live here.

LET MY SPIRIT SOAR • 1984

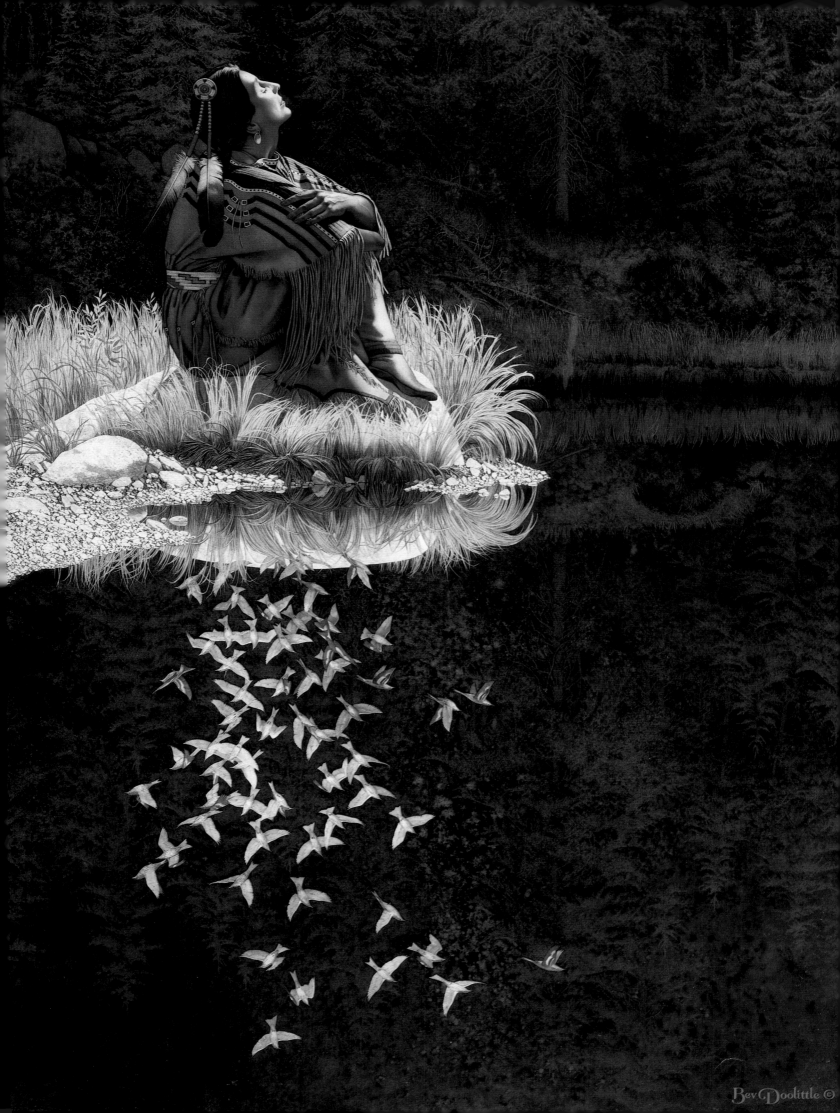

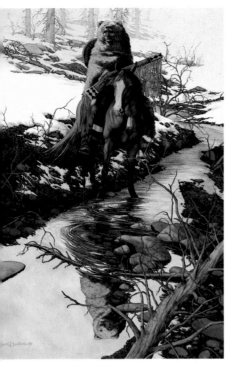

Besides horses, what does Bev Doolittle like best to paint? "Bears, eagles and wolves," she says. "The Big Three. Because they are wild. They say wilderness. Seeing the wilderness go is depressing. At least in my paintings, I can save something of the wild."

People of all ages respond strongly to *Spirit of the Grizzly*. When a teacher invited her seventh grade English classes to write about it, more than one hundred papers were turned in. Even "reluctant writers" were inspired. Interestingly, some saw the Indian as a "young brave" while to others he was "the battle–scarred warrior, old and proud." All saw reflected in the water "the spirit of the grizzly."

One youngster commented on "the sound of trickling water against the cold rocks" and it was a certain rocky stream seen in late winter that gave Bev Doolittle the idea for painting. In the photograph she took of the stream, the melting snow along the shore is pristine, but there might have been bear tracks. Bev remembered other rivers, other bear tracks. She decided to paint not just a bear but the spirit of the mighty animal.

In her mind's eye the image was clear—but a few practicalities remained. A model was needed. Husband Jay obliged, his steed a stool, his lance a dowel; and although in the finished painting only the rim of it shows, a painted cardboard shield (handcrafted by Bev) was slung over his shouder.

When Bev tells the story she likes to point out that she needed a grizzly bear, too, but had to do without "because he wouldn't fit in the garage."

She enjoys the responses this painting engenders. The letters, sales and comments assure her that she has managed to convey something of the Indians' respect for the mighty grizzly. Saving starts with respect.

In Bev's world none of the above precludes having fun so she made baby Jayson a "bear-skin" to wear so that like the Blackfeet (who donned real fur and claws) he might possess the spirit of the grizzly. It may or may not mean anything but his mother reports that "the kid wouldn't take it off."

In *Hunting Party*, an early painting, Bev Doolittle experimented with a technique which allowed her to overcome some of the limitations of transparent watercolor. By masking certain areas with a rubberlike substance which could later be peeled off, she was able to

Hunting Party

*Under a gold canopy of
Aspen leaves,
Single file on horseback,
Unseen they hunt
The land's lost generosity,
The keeping of promises.
Moving silently
Back and forth
Across the shaft of sunlight
We call time.*

crowd a painting with detail without losing the sense of light filtering through. Even when she was working out a problem she had a story to tell, a mood she wanted to convey.

In almost every Indian tribe, the wolf was admired for its loyalty, stamina and ability to track. In Indian sign language the gesture for scout was the sign for wolf, and Crow warriors who were "like a wolf" were highly esteemed. But being like a wolf meant more than wearing the sacred wolf skin. It meant studying the ways and habits of wolves and focusing all one's energies on living the way of the wolf.

The same single-minded diligence characterizes Bev Doolittle's approach to art. In *Wolves of the Crow,* the viewer gets a sense of streaking speed, but the effect was not achieved quickly. In addition to research, the painting involved dozens of preliminary drawings, sketches and color studies, and the final brushwork took months.

In the companion portraits of *Guardian Spirits,* a Blackfoot Indian rides forth in full dress, adorned with the feathers, pelts and claws of his animal protectors. Next we see him in the moment he has become aware of danger, warned by the spirit of the wolf he wears as headdress. Fearless as the mountain lion whose pelt he uses as a riding cloth, he turns his face toward us and we see ferocity and cunning, wisdom and strength come alive to ride with him. There are eighteen spirit animals watching over this warrior.

Over the years, Bev Doolittle has received many letters from native Americans, some of whom are active tribal members and others whose parents or grandparents were. More often than not, these letters comment on Bev's ability to see things the way they do. The tribal secretary of the San Luiseno Band of Mission Indians sums it up: "We are not 'noble savages' but fellow human beings and she has depicted us as such."

Writing to Bev, another Indian wants her to know, "Your painting, *Season of the Eagle,* is really powerful. I showed it to my spiritual advisor and he said: 'Some people blessed with the ability to do art, draw what *they* feel. This woman is drawing the vision of how *we* see the connection of nature and man.'"

Another letter tells of showing the medicine men "a few of your works I had collected in books. It made them feel good and brought memories of stories they had heard passed down and they said your work is a beautiful story, each one is more than just a painting. So now when I am in a Ceremonial, they pray for you to keep up the good way you were blessed with."

The first and second graders of the Quinault Nation observed: "We found Indian and eagles in *Sacred Ground.*"

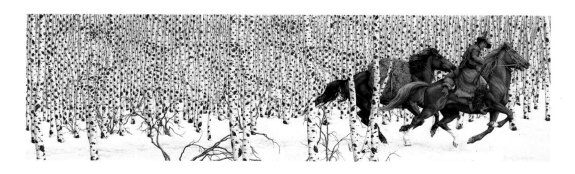

AUTUMN GLOW • 1977

"Aspen leaves do magic things in sunlight. It is a tree that has always delighted me — so varied in its many aspects and yet so distinctive in its design that even one tree can provide literally hundreds of different effects, whether in sun, or snow, or shadow, or moving in the lightest wind, or just the stark variety of patterns in the bark."

— Bev Doolittle

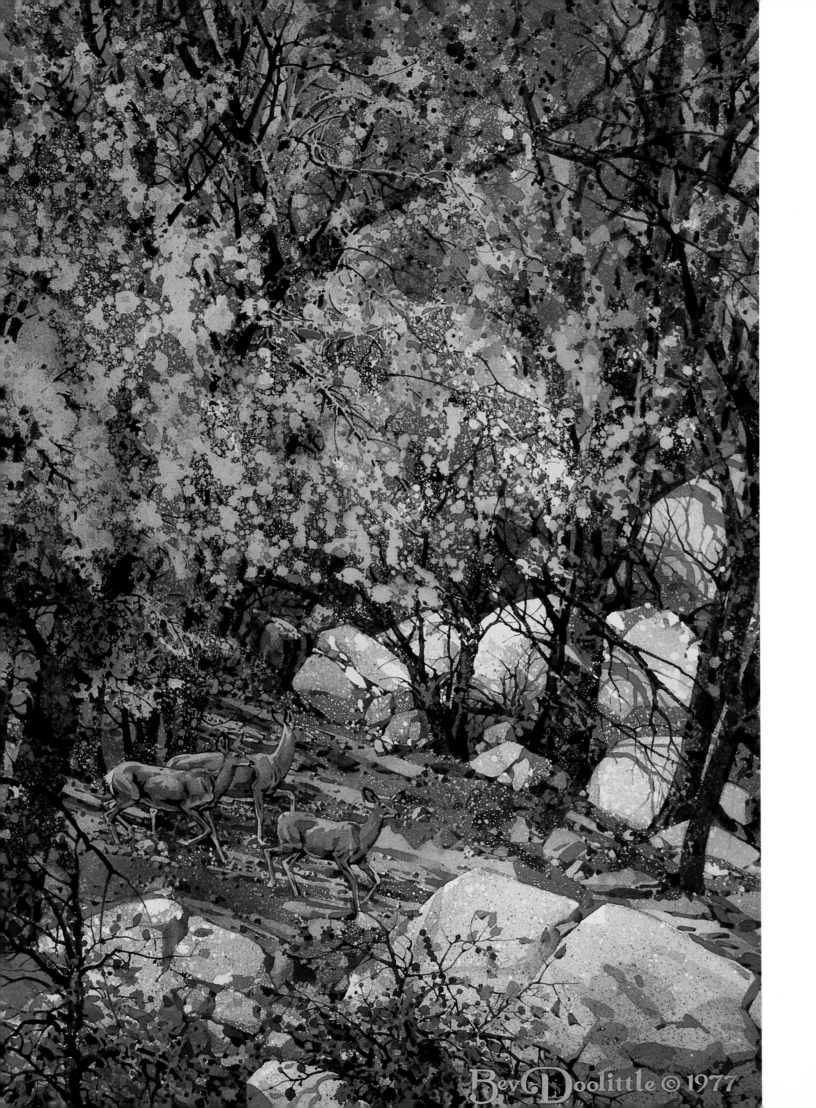

RUNS WITH THUNDER • 1983

*"Indian names often have hidden
meanings. The sound of thunder and
the pounding hooves of a buffalo
herd on the run from hunters are
very similar. This Sioux warrior, like
his own totem, Runs With Thunder."*
— *Bev Doolittle*

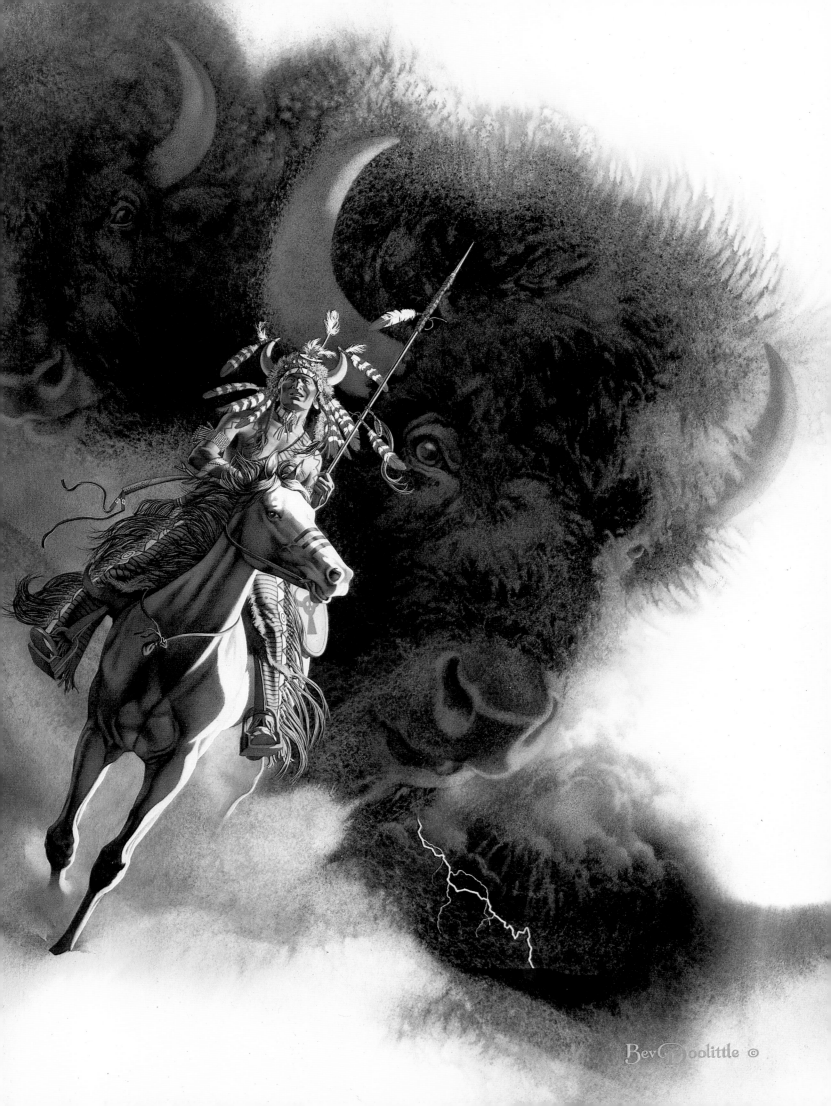

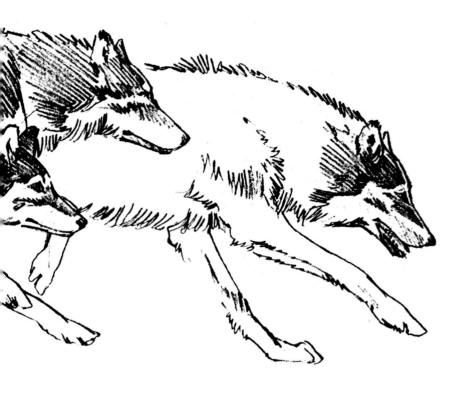

**WOLVES OF
THE CROW**
(Sketches)

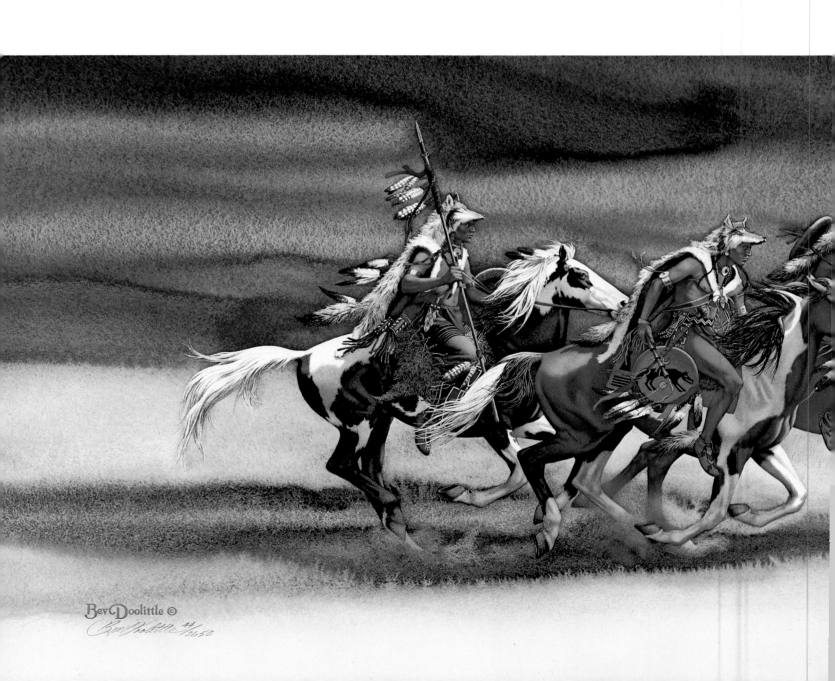

WOLVES OF THE CROW • 1985

*"These Indian warriors have attained the
honorable status of 'scout.' Wearing the
sacred wolf skins, the Crow scouts call upon
the wolf spirits to help them hunt, track, or
succeed in a raid."*
— *Bev Doolittle*

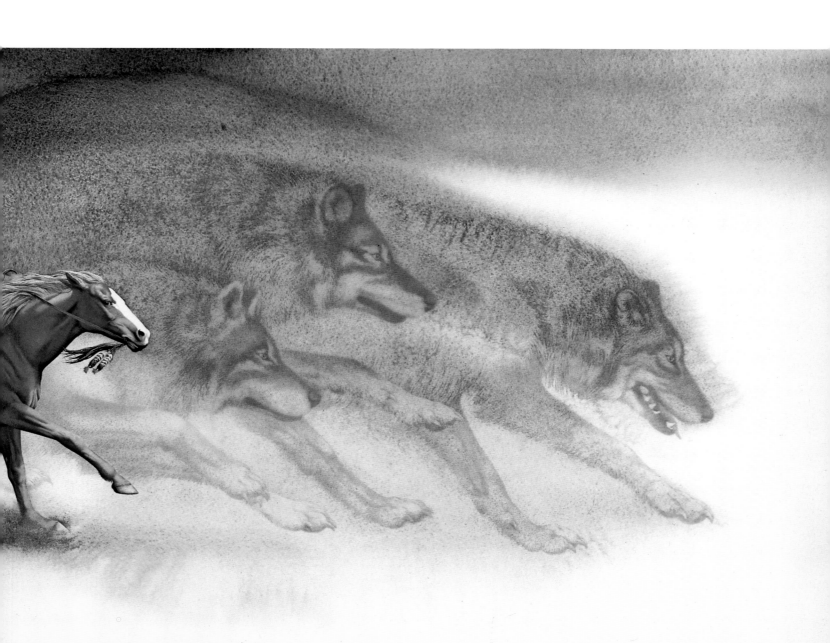

THE GOOD OMEN • 1980

"Occasionally, while hiking in the desert near my home, I'll be lucky enough to see a golden eagle. The sight of this great bird soaring free in its natural environment is always inspiring to me."
— *Bev Doolittle*

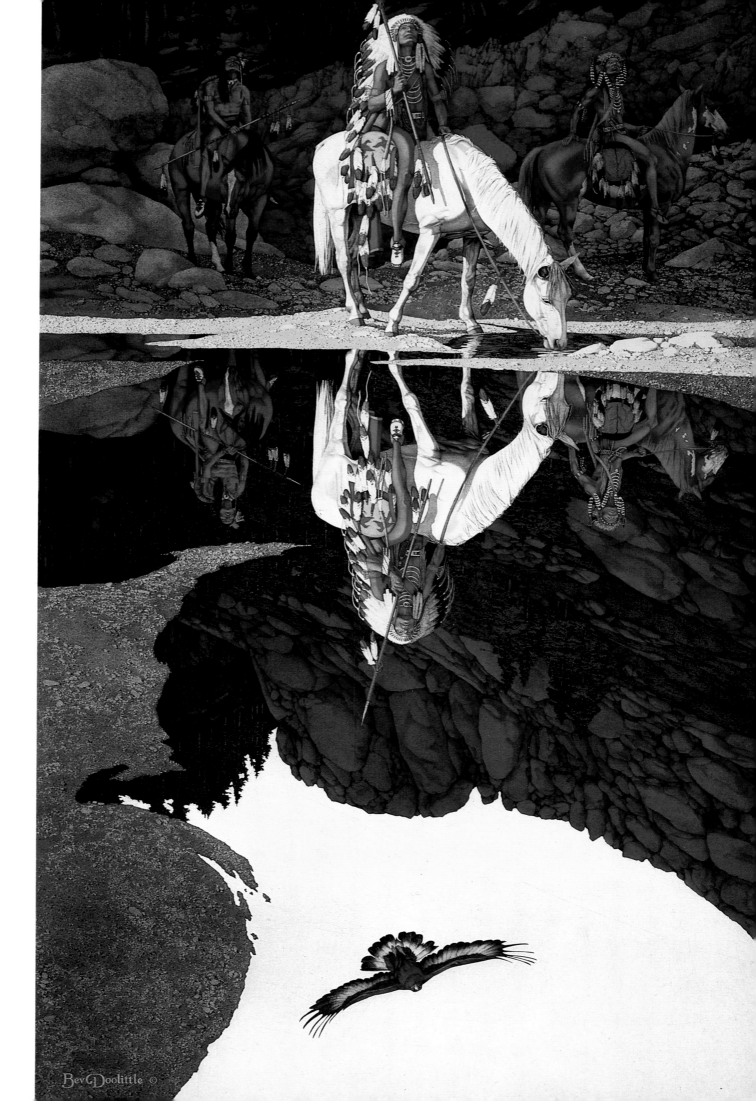

Bev Doolittle ©

SPIRIT OF THE GRIZZLY • 1981

*"By wearing the fur and claws of the great
hunter, the Indian hopes to share a part of its
powerful spirit. I decided to paint this Black-
foot Indian beside a cold mountain stream,
flowing so slowly in deep winter that it creates
a reflection of the warrior who has truly
wrapped himself in the spirit of the grizzly."*
— Bev Doolittle

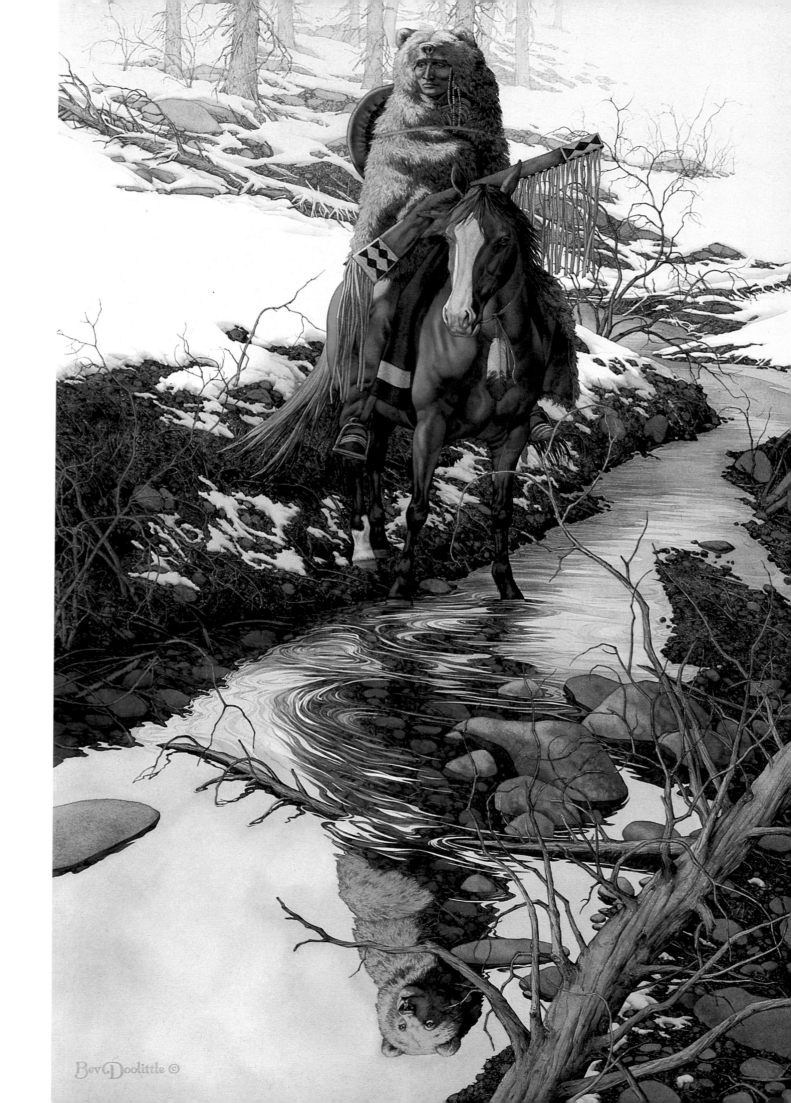
Bev Doolittle ©

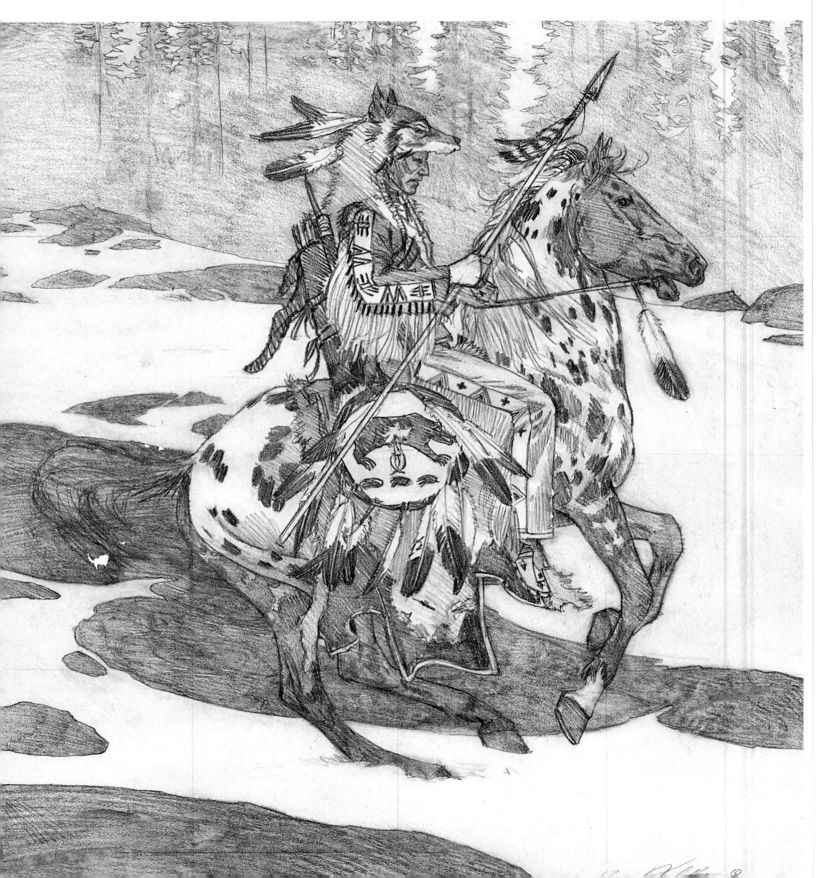

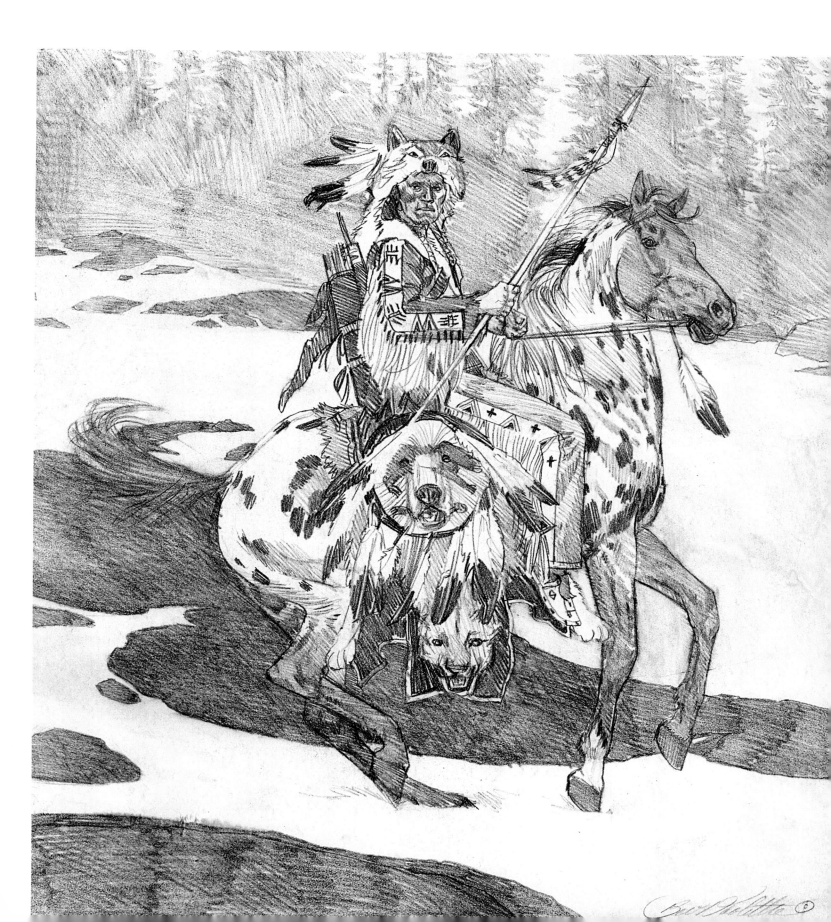

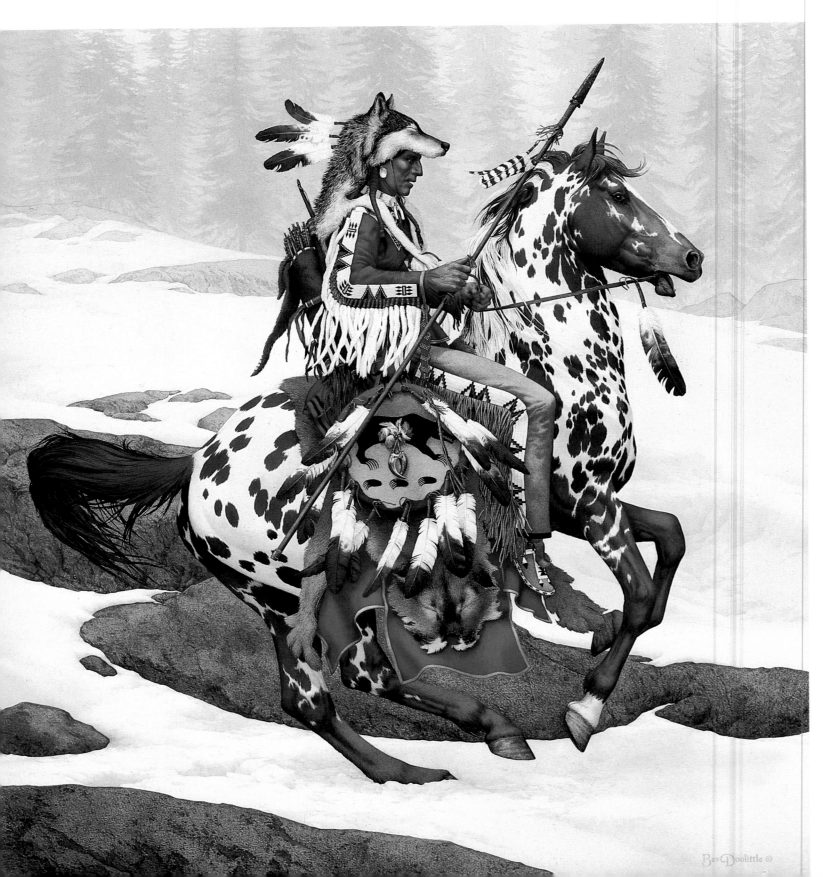

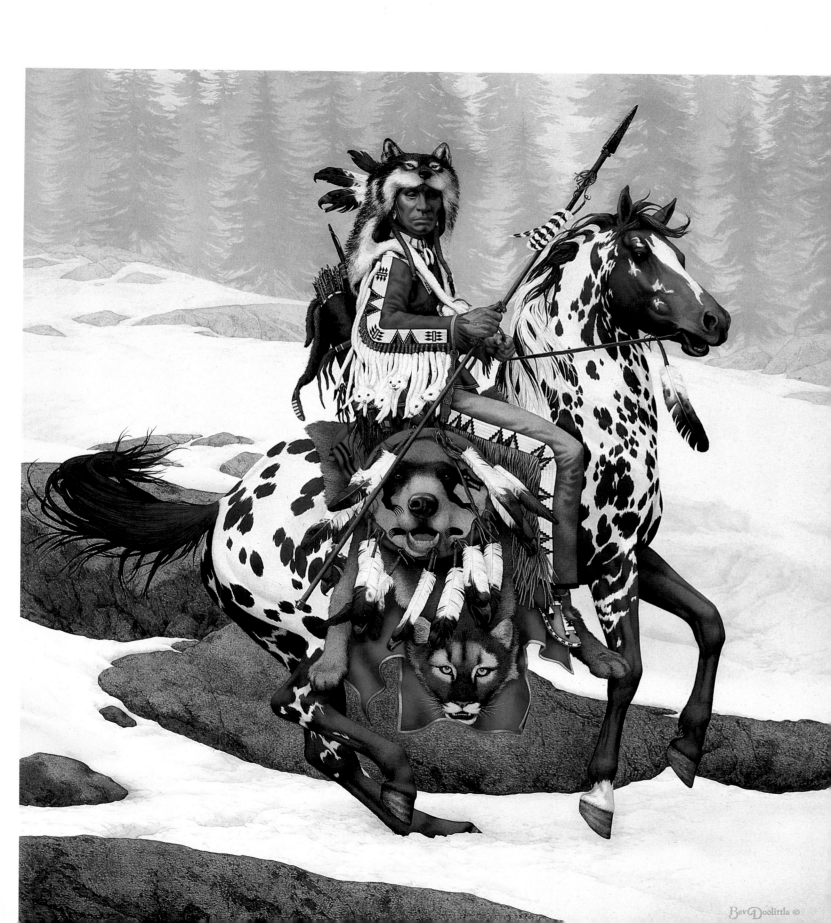

10
KEEPING THE MAGIC ALIVE

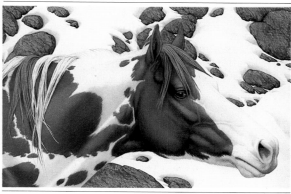

*"Bev Doolittle...unique in a field
no one can even define."*
—Judy Hughes

Where do you get your ideas?"

The question, often asked, is one that Bev Doolittle finds easy to answer. "My paintings are rooted in my own experience." Bev, of course, experiences places and events in a unique way.

From the day they set off as "Traveling Artists," Bev and Jay have sought new experiences to spark painting ideas. At first, it seemed to Bev that she was painting faster than she could live. Now her life races along, crowded with new experiences, and she wonders if her brush will ever catch up. Instead of depleting her store of ideas, she is adding to it. But unlike the stereotype of artist–as–dreamer, she does not count on her muse to remember and produce a concept in the misty future when one is needed. Bev's approach is more that of a thrifty housewife putting up preserves. Every painting idea is described in longhand on an index card and carefully filed away along with thousands of catalogued photos. At first it was easy, a pleasant way to spend an evening. Now it is a prodigious task to be fitted between demands for television interviews, gallery appearances, print signing, and the pleasure of doing things with Jayson.

JAYSON—AGE EIGHT

Again teamwork turns out to be the answer. Since Bev shares most experiences with Jay and they discuss most of the painting ideas that result, he is ideally qualified to serve as archivist and often does so. Happily both Doolittles have a talent for organization and can usually lay their hands on anything they're looking for after exchanging a few of the unfinished sentences used by people who know each other well.

"Remember that photo of the jackrabbit?"
"Cottontail."
"Right. They want it for that article on—"
"Camouflage. You can also give them—"
"Snowshoe Hare. Is that too many?"
"Rabbits? Maybe. How about—"
"The grizzly? He probably won't—"
"Show up enough? I think he will."
"Great."

If *Pintos* brought changes in Bev Doolittle's life, the Personal Commission Print concept brought more. The idea that a retail gallery could get as many prints as they could pre–sell by a definite cut–off date made a big difference in their marketing approach. Many galleries went all out with their advertising, utilizing television, radio and billboards along with traditional print media and direct mail. As a result many more people saw and were attracted to Bev's striking images, and record–breaking editions of Doolittle prints were required to meet the demand. Bev was expected to continually come up with new and exciting ideas for Personal Commission Prints. She wanted to do that anyway. What *was* confining was the need to concentrate solely on major works. There was not time for playing around, splashing paint on paper, painting outdoors with Jay and Jayson. She almost couldn't do it anymore; her strong, sure, mature style had taken over.

To put a little spontaneity in her artistic life, she decided to take a week–long sculpture course in Scottsdale where her favorite sculptor, Sherry Sander, was teaching. It was love at first touch. The malleable clay. Push, pull, twist. Create an animal and command it to sit, crouch, run, stretch until you found the pose you liked best. Doolittle's classmates were astonished at the way she could produce lifelike sculptures in only a day. Dismissing these creditable little pieces as practice exercises, Bev points out that she has always seen animals three–dimensionally, has always been interested in the way they move and change when viewed from different directions. What she gained in class is the certainty that some day she will do bronzes.

For now, it is a challenge that waits in the wings and sometimes makes her smile as she signs her name 69,996 times.

Stress is a word Bev Doolittle uses rarely, and like most negatives, it is not a concept she invites into her consciousness. Yet there is no denying that as her work became more popular and her name more widely known, the demands on her time, energy and patience increased. A glance at her daily journal tells the story.

Feb. 19, Sunday 8 a.m. At gallery to pre–sign matts, books and insert cards. Met a few special customers—deaf mutes. "Talked" about my work on paper with pen.

9:30 a.m. Rushed to airport to catch plane. Drove to motel. Brunch with gallery people. At gallery to pre–sign books and matts for customers.

2 p.m. to 8:30 p.m. At show. Big crowd started forming line at 1 p.m. Some people in line three to four hours not counting the two–hour drive it took some folks to get here. Three TV stations interviewed me at show.

11 p.m. Channel 2 (CBS) showed me on 11 o'clock news. Watched at restaurant bar after dinner. Great coverage.

11:30 p.m. to 1:30 a.m. Finished signing insert cards in motel.

Left to her own devices, Doolittle would probably not have kept so mundane a journal–after–the–fact. But fame had brought her fortune, the government wanted to know about it, she acquired "a tax man," and soon found herself documenting business expenses and attempting to quantify inspiration. "I hate it," she says, echoing artists everywhere since time immemorial.

But, she says, sounding like herself, "We must not be irresponsible." The charge could hardly be leveled. Aside from a few nice clothes for television and gallery appearances, Doolittle wears department store jeans and does much of her shopping by catalogue. Her car is a bottom–of–the–line Honda without a car radio. She explains that she doesn't need a radio because when she drives her son to school she wants to talk to him and on the way home, she needs to think. Jay drives a pickup because "being artists and living out of town means we have a lot of stuff to haul." Their two–bedroom house is inexpensively furnished and devoid of gadgetry.

The Doolittles are not "making a point." They are simply disinterested in mass–produced objects, preferring to spend their money on people, experiences and fine art.

In recent years, they have been having glorious fun doing so. Because on camping trips in the High Sierra Bev and Jay often found themselves wishing one or another of the family were with them, on one recent trip they invited everyone to come along. It was a family reunion to remember: fourteen people, ages seven to seventy, riding horses up into the mountains; sitting around a campfire swapping family reminiscences; sleeping under canvas, and getting up to flapjacks and jokes and hikes to admire the view. "It might not have worked," Bev said, "but it did. You have to try."

Of the new things the Doolittles have tried, they are especially keen on scuba diving. As might be expected, Bev was thrilled to discover a new world underwater. She was dazzled by the colors and shapes, the interweaving of light and shadow. Here was a whole new way to play the camouflage game. She took photos and made sketches and color studies for future paintings. Again, the Doolittles took Jayson with them. It seems to be impossible for Bev Doolittle not to share. Perhaps that is why she paints.

As their income increased, the Doolittles have been able to give more to their favorite charities. These are mostly in areas of conservation, education, and support for American Indian projects. Bev gives anonymously and is firm about refusing solicitations or accepting recognition. In recent years, however, she has been very privately consolidating personal philanthrophy with a focus on the land, children and native Americans. For a variety of good reasons, among them sensitivity to the feelings of others and her own need for time and solitude to paint, this is one area Bev refuses to mention or discuss. Pressed, she will admit only to a desire to "give back."

In 1988 Bev and Jay Doolittle went to Tanzania with Simon Combes, a Greenwich Workshop artist who specializes in painting African wildlife.

For centuries, going to Africa has been considered one of the world's great adventures. It certainly was for Bev Doolittle. The enormous tracts of untamed country, the incomparable Serengeti migration, the countless birds and animals might have been created for her special way of seeing and painting. Camouflage and mystery. It was all here on the most awesome scale. Only one thing was missing. Jayson. Six months later Bev and Jay returned to show their six–year–old son the wonders they had seen.

The trip meant as much to Jayson as his parents hoped it would. Old Africa hands could have predicted as much, for what small boy could resist the sight of a thousand Grévy's zebra cavorting on a hundred–square–mile grassy floor framed by steep crater walls, and wildebeests straight out of a fairytale book, to say nothing of Babar the elephant in person enjoying a mudbath with friends. Jayson painted it and Bev recorded it on film and in her notebooks as reference for future paintings. She even took photographs of animal tracks. Who knows where they will lead?

Bev is fun to be with because her natural inclination is to accent the positive. She talks of exciting adventures, beautiful sights, happy events, editing out items like Jayson's chickenpox and the enormous amount of work that must be done on a painting she is being pressured to produce "yesterday." It's easy to imagine she spends most of her time flitting about the world, when in reality the trips she cherishes are usually two or three weeks in duration and are taken once or twice a year.

The less glamorous truth is that she spends countless hours sitting on a wooden stool facing a drawing board very much like the one she worked at in that Los Angeles advertising agency over a decade ago. But everything is different: what she is envisioning; what she is painting; and what she sees when she lifts her eyes—Jayson doing a puzzle on the floor; through the window, sagebrush and cottonwood and desert sky; on a table, a model of the new house they are building on the rocky edge of the wild.

If we are not precisely what we buy, our purchases at least tell much about us. For a building site, Bev and Jay chose ten acres of boulders bordering the Joshua Tree National Monument. This is a spectacular wilderness area with many trails for backpacking and some of the best rock climbing in the world. The terrain includes vast low desert stretches, great gardens of cholla cactus, mountainous areas, high plateaus strewn with boulders and forests of joshua trees. Stephen Trimble, writing of Joshua Tree, comments, "This land makes a challenging home."

For Bev and Jay, the challenge began with trying to find someone to design a house to fit their unconventional site. "House" is almost not the right word to describe what they envisioned. They wanted to live in a structure that was part of the desert, that grew out of it, that would age and weather with the boulders and, like them, grow more beautiful with time.

With their objective defined, they realized that what they were looking for in an architect was someone with an environmental philosophy that matched their own. They found it in Kendrick Bangs Kellogg who works in the tradition of Frank Lloyd Wright, using natural materials and curved designs that match the undulation of surrounding hills. Besides being impressed with Kellogg's sensitivity and creativity, the Doolittles were intrigued with his assertion that he considers the owners an essential feature of organic architecture and encourages his clients to be actively involved in the construction of their own homes.

From the first, both Doolittles *have* been actively involved. In an early letter Jay analyzes their lifestyle: "Bev and I are both artists. The subject matter of our paintings reflects our love of the North American wilderness. The selection of our building site reflects this love of solitude. We do a minimum of entertaining and usually for no more than one other couple. Most of our time is consumed with painting and raising a young son. It would be accurate to describe our lifestyle as quiet and private. We feel this rocky piece of desert is a very special place and we want to do it justice."

More than a year later, when the architect had completed the blueprints, Jay built a scale model of the house, and wrote to Kellogg: "The roof and column shapes are absolutely beautiful. Each one is a piece of abstract sculpture. They are like giant bird wings or maybe the hull of a sailboat. If you peek up through the inside of the model you can see these overlapping curved shapes like clouds against the sky or lily pads as they might appear from beneath the water. It's really starting to sink in. This thing might actually be the most beautiful house ever designed."

The Doolittles are not surprised and certainly not daunted by the fact that the most beautiful house ever designed is likely to take many years to build. In some instances, portions of the mountain must be moved. Wheelbarrows rather than bulldozers are employed much of the time. It is an exciting project and the whole family visits the site daily to check, speculate and dream. Here we shall create an oasis of green plants, here we will work, here we will swim and from here our own little waterfall will fill an outside waterhole where desert creatures may come to drink.

Since time waits for no house, the Doolittles have modified their current living arrangements. A new roof, work space and storage have been added to their Joshua Tree house and a daily commute has been added to their lives so that Jayson can attend a small progressive school in Palm Springs.

About school, Jayson is unmitigatedly enthusiastic, telling this reporter: "I go to school every day and there is no day I hate." Obviously he has inherited his mother's optimistic viewpoint. He also seems to have inherited his parents' artistic talent. When he was only three years old, he commemorated a trip to British Columbia with a recognizable drawing of a caribou, and recently he celebrated Halloween with a pen–and–ink rendition of a house haunted by dinosaurs. His abiding preoccupation with prehistoric animals may, of course, presage a scientific career but he does love to draw and paint—which is more than a little handy in a household where everyone does mostly that.

To protect their cherished privacy in the face of increasing needs for Bev to interface with the public, the Doolittles have taken an apartment in Palm Springs. Radio and television interviews are conducted here, and guests are put up overnight. The apartment also serves as a studio where Bev can paint uninterruptedly for the six hours between delivering and collecting Jayson from school.

Jay copes with day–to–day hassles and the couple's now voluminous business affairs at their Joshua Tree base. The phone rings constantly. He threatens to bundle the paperwork into a knapsack and hike into a deserted canyon for peace and quiet. Still, both he and Bev continue to enjoy meeting and hearing from collectors and people who admire Bev's work. Her paintings are, after all, a form of communication and she finds it gratifying when people understand and respond.

Her mail includes poems and drawings inspired by her paintings, a handcrafted replica of the shield in *Guardian Spirits*, a request to use slides of *Pintos* and *Two Indian Horses* to demonstrate to radiologists that in the art and science of mammography, there are two vital elements: "The ally is Perception. The enemy is Distraction," this letter says. "I need not draw parallels for the master, herself."

A friend from twenty years ago reads a magazine article and writes, "Can it be, is that really Bev?? The hottest artist in the country. That's sure a far cry from the bouncy smiling teenage girl I remember who used to go to Santa Anita Race Track to sketch and paint horses, or the two creative 'starving artists' who set off to do their own thing in an old pickup truck!"

Bev is the first to agree. Looking back at her career to date, one thing stands out. When faced with a choice, she always picked the option that allowed her to do the best paintings. Time and money were always less important considerations. She could have done simpler, less time consuming paintings for the outdoor art fairs and made more money. She could have continued doing the "You–and–Me" paintings. She could have avoided complex sub-

jects and produced more published prints each year. But she did not choose those routes. It was a conscious choice but she says it was not a difficult one.

Perhaps what we are looking at when we see an almost unbelievably sunny disposition is simply a soul undivided. When Bev decided to be an artist, it was settled. She could not and cannot be persuaded to compromise or take short cuts. Try to rush her and she digs in her heels. "Art matters," she says. "Deadlines don't."

And both art and life are long. One day she will do bronzes. And one day she will paint Africa. But she will still paint the western scenes she loves. Bev Doolittle's upbeat, energetic viewpoint gives short shrift to the concept of either–or. She's a painter *and* a wife, mother, celebrity, friend, backpacker, and paddler of Arctic rivers. Her life and her paintings evade typecasting as gracefully as one of her camouflage subjects eludes the eye.

O n the tenth anniversary of *Pintos* Bev Doolittle celebrated in a way only she would think of and could do. She created a dazzling painting using exactly the same elements—pinto ponies—to demonstrate how far she could take the camouflage technique.

In twenty-four separate vignettes, beautiful little paint ponies are seen close up and from afar, in every position, from every angle. Each small portrait is complete and could stand alone. Together the images spell out a message which can be read many ways. For some it will evoke childhood's lost playfulness. For others it will restate the need to look for the obvious in all its hiddenness.

Like all Doolittle paintings, *Hide and Seek* reminds us that there are many ways of seeing.

HIDDEN THINGS

I sing of hemlocks whispering mysteries,
Of meadows green with promise,
Of lakes with secrets,
Of mountain peaks in touch with eternity,
Of solitude filled with murmurings
 we can never quite hear,
Of presences that hover
 just beyond the edge of perception,
Of meanings etched in snow,
 transcribed with wings,
I sing the truth
Of hidden things.

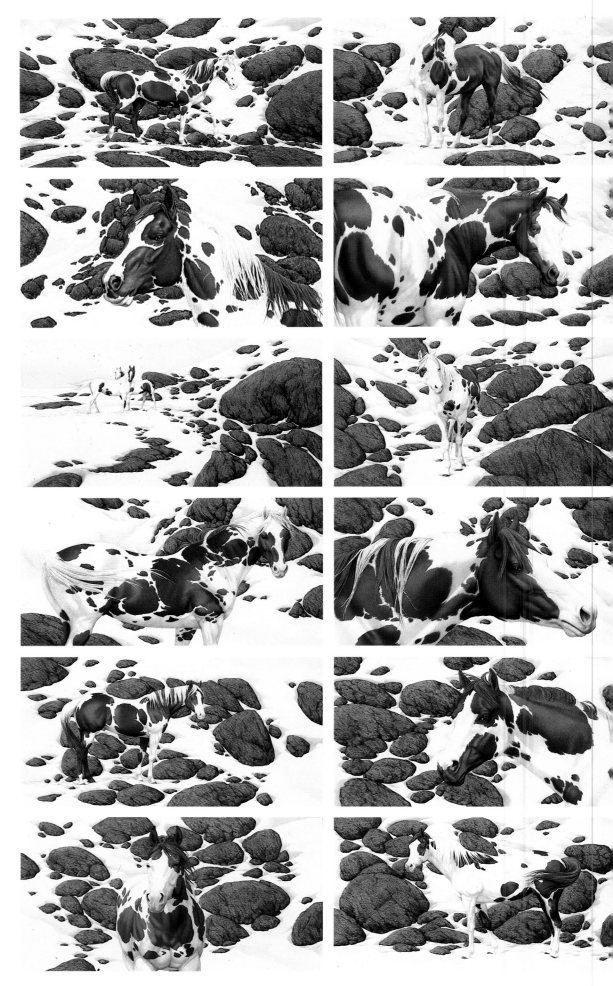

HIDE AND SEEK • *1990*

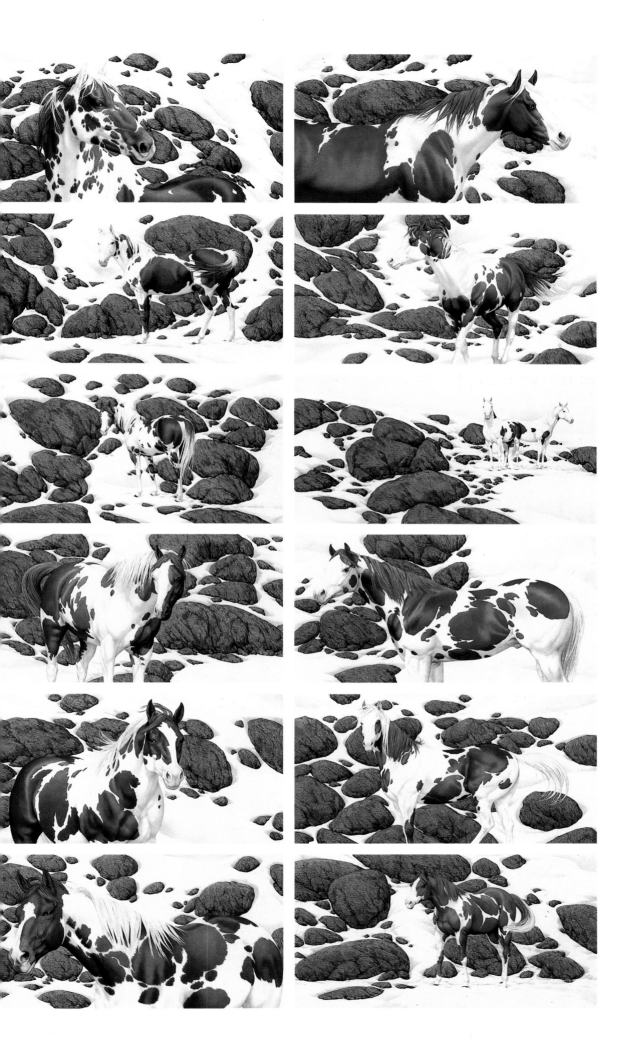

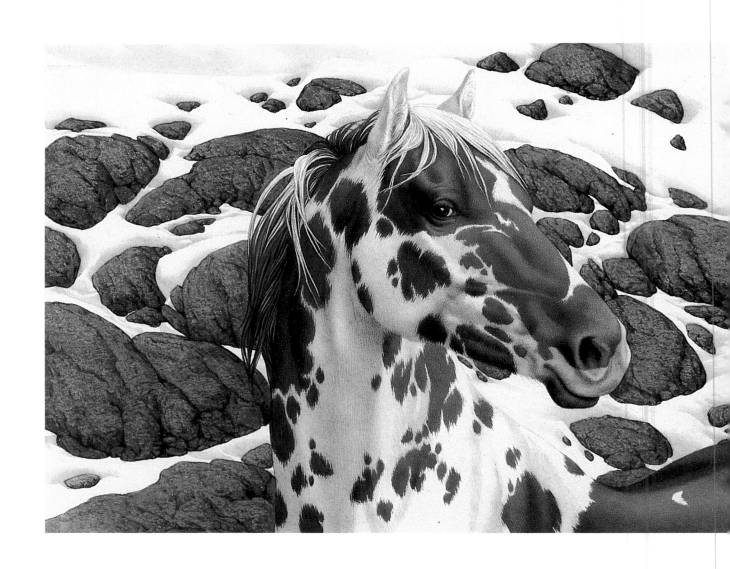

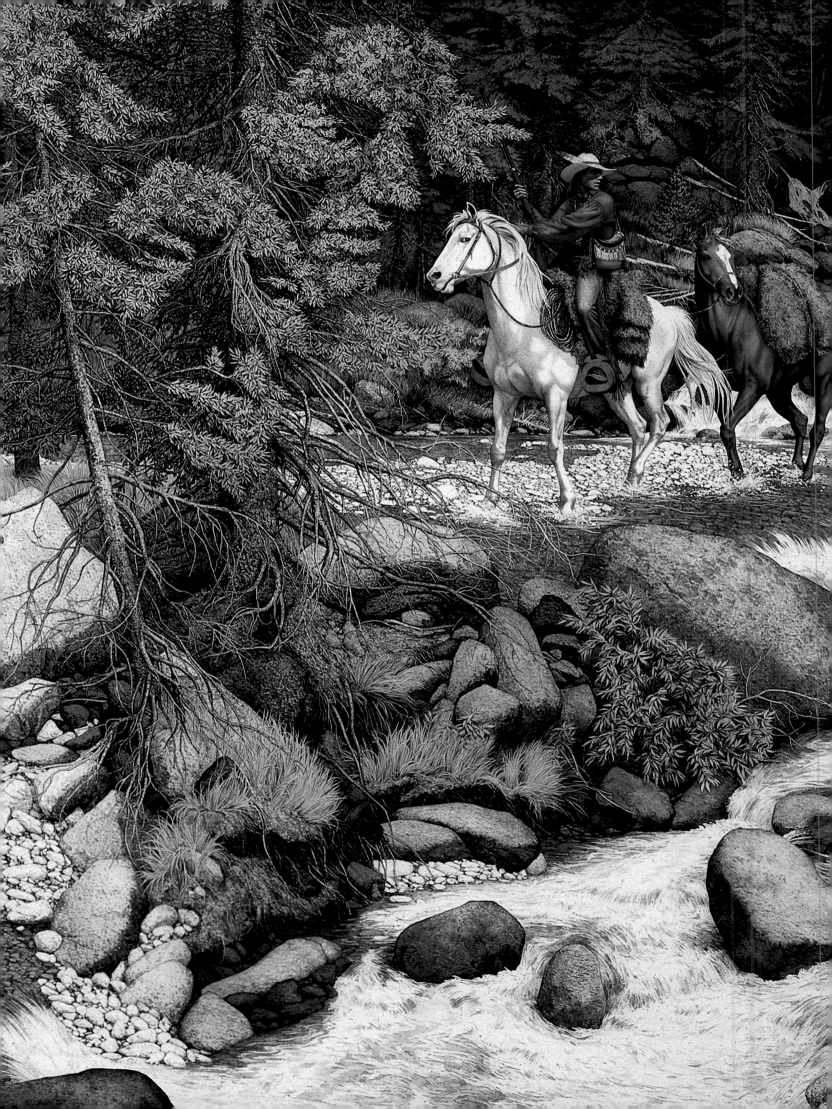

INDEX